*TIME
IS THE THING
A BODY
MOVES
THROUGH*

TIME
IS THE THING
A BODY
MOVES
THROUGH

T FLEISCHMANN

COFFEE HOUSE PRESS
Minneapolis
2019

Coffee House Press books are available to the trade through our primary distributor, Consortium Book Sales & Distribution, cbsd.com or (800) 283-3572. For personal orders, catalogs, or other information, write to info@coffeehousepress.org.

Coffee House Press is a nonprofit literary publishing house. Support from private foundations, corporate giving programs, government programs, and generous individuals helps make the publication of our books possible. We gratefully acknowledge their support in detail in the back of this book.

LIBRARY OF CONGRESS CATALOGING-IN-PUBLICATION DATA

Names: Fleischmann, T., 1983– author.
Title: Time is the thing a body moves through / T Fleischmann.
Description: Minneapolis : Coffee House Press, 2019.
Identifiers: LCCN 2018040653 (print) | LCCN 2018059169 (ebook) |
 ISBN 9781566895552 (ebook) | ISBN 9781566895477 (trade pbk.)
Subjects: LCSH: Fleischmann, T., 1983– | Authors, American—
 21st century—Biography
Classification: LCC PS3606.L453 (ebook) | LCC PS3606.L453 Z46
 2019 (print) | DDC 818/.603—dc23
LC record available at https://lccn.loc.gov/2018040653

PRINTED IN THE UNITED STATES OF AMERICA

30 29 28 27 26 25 24 23 8 9 10 11 12 13 14 15

TIME
IS THE THING
A BODY
MOVES
THROUGH

SUMMER

I leave Buffalo when the moon is still out, and on the long bus ride south I find myself unable to read. I often can't read on transit, the presence of so many other people demanding a half-attention that interferes with the attention a book requires. Instead, I look at Scruff, where the hills and plateaus offer just blips of men. Most of them are stationary, so the bus's crawl puts them at steadily increasing or decreasing proximities, of two hundred miles and then one hundred and eighty, of one hundred and eighty and then one hundred and sixty, of eighty and then ninety. One guy seems to travel a similar path, a similar speed, either following me or preceding me, thirty-one miles away, thirty, thirty-one.

On the grid I keep checking an account that features three gray-haired men, their arms around one another, each a bottom. "Top who wants to join our family. Who does like to play games and believes you can love more than one person. Is ok with having sex only inside our group and so on." Further into the profile, each describes himself, although these short paragraphs seem only to further conflate their lives—they all like hanging out, dogs, and especially their pugs. "I like to read, write, and relax with my boy-friends," one says. Another, in a typo, says he likes to "cook and do choirs." They are all smiling, beaming really, but the one in the middle of their embrace, the shortest one, his smile is the widest.

Bottoms seeking their top, I imagine them all in a king-sized bed, asses in the air, waiting. And when the two met the third: the realization that he, too, was a bottom, and the disappointment that must have given way to familial, romantic love. Does the newest bottom fear he is there only to heighten the appeal to their eventual top—not there as a he, but as one of them? He must run to the other rooms to get the lube, their double-headed dildos (but this an intense joy, so a top might puncture it; it is good they are isolated on this plateau).

I came to Buffalo to see my friend Simon in his new home, but also to visit him, a guy I love in my own weird way, without the potential of sex charging our time. "We'll never have sex again then, we'll just take that off the table," I said over the phone a month earlier, years of occasional fucking ended with relief instead of histrionics. These expectations cleared up, I arrived to find his body the same muscled, pale thing it had always been, his smile the same quick grin and his jokes the same bleak insights. I settled into this new arrangement, although the relief from touch felt to me like an ache, or like the auditory hallucination that would linger after I listened to the same song on a loop all afternoon.

We wandered the streets of Buffalo gay pride as two close friends, friends who knew each other to be just that as we played pool, which we did, poorly and drunkenly. We held the doors open for one another and lit our own cigarettes. I insisted on a fancy meal, my treat, and we followed cocktails with cocktails, and when our feet touched under the table it seemed only to underscore what we would not be doing that evening, rather than tantalizing the possibility of what we might do. We still laughed and we still complimented each other's shirts and we still talked books on our long walks. Friendship was an easy enough place,

our relation to one another locatable in language—"a friend visiting from out of town," Simon explained to the men who hit on him at bars. But we had always been friends, a word that reduced our odd joining to something less than what it was.

Before boarding the bus, I sat on Simon's bed and he sat a few feet away, at his kitchen counter. We shared a carafe of coffee with *Democracy Now!* humming on a radio by the window. We talked about his large taxidermy dog, Germanard, a German shepherd who had died protecting his former owner during a home invasion and that Simon had put in storage. He got ready as I got ready, and he went off to the coffee shop where he worked, and I went to the bus, leaving while the morning held its chill, then taking my jacket off and crumpling it into a pillow to use on board.

Scruff offering me nothing, I scrunch up into my laptop and open the thing I'm writing, a project I began in the erotic vibrations of my friendship with Simon several years ago. It's not that I believed our relationship transcended anything, exactly, or that it would become anything but what it was—we were always clearly a pair, we two friends. I was writing instead to see where my excess of desire would go, when a simple thing like falling asleep with my arm across a guy I loved meant I would buzz with anticipation of falling asleep all day. I tried to write in such a way that there would be room for that buzzing along my words, even if I did not always find room for it in my life.

For the month of July, I stay in a room in an apartment in the Lefferts Gardens neighborhood of Brooklyn.
There are two other people who live here, one a close friend and one an acquaintance.

I share the room with a third friend, Simon.

He, like me, thinks often of the breaking of ice or glass.

In the living room is a small round table with a lamp at its center.

Surrounding the lamp is a pile of individually wrapped candies, thirty or forty maybe, all of them a crisp and glistening blue.

They are quiet until you touch them, and then they crinkle.

The first time I walked up to *"Untitled" (Portrait of Ross in L.A.)* I stood before the piece by Felix Gonzalez-Torres for two or three minutes, a few feet back.

A friend had earlier explained it to me, so I knew I was allowed to step forward and take a piece of the candy.

I selected one wrapped in bright yellow foil.

I knelt, lifted it, and fingered it for a moment before unwrapping.

I placed it in my mouth.

I sucked at the candy as I continued to look at the pile, slightly diminished.

I felt for a moment an acute sense of loss and beauty, each indistinguishable from the other.

The candy was very sweet, and it was melting.

I have never properly lived in Brooklyn, but spend time here every season or two.

I come to see the doctor who gives me the hormones that make my body different.

New York is a city where people talk often of how it was.

I glanced the place for years, first in poetry and novels, then visual art,

the idea of it suggesting something like possibility, so far from what I knew in small-town Michigan that it suggested I could be possible, too.

This spring, I came during an exhibit at the New Museum titled *NYC 1993,* and made plans to attend the show with my friend Benjy the day before his own opening in Chelsea.
Instead, I stayed out the night before until sunrise, Jägerbombs and drunken arguments with strangers, and slept into the next afternoon with Simon's arm slung across my body.
Now, returned to the city for the summer, I see that the Whitney hosts a similar exhibit: *I, You, We,* a survey of the museum's collection from the eighties and early nineties.
When I attend, I walk the lopsided circle of the show twice, embarrassed by my sentimentality.
I try to think of the world when the art was made, and I try to think of now.
It's odd, when everyone seems to look back to the same time at once, to realize collectively that it can be seen from a new perspective.
It reminds me that we're all telling ourselves a story, as we try to understand where we've arrived.

There is a heat wave in New York City.
One day, as I'm suggesting I'd go again to the Whitney if they wanted to see the show, two friends and I become incapable of leaving Simon's small, air-conditioned bedroom.
We lie together on the bed—
Simon beside my left arm, our friend Henri beside my right.
In the past I have imagined what it would be like to date each of them.
In the past I let this affect how I behaved when we were together, rather than letting any of us be who we are,
horny and joined somewhere between the platonic and the erotic.
We scroll through gay hookup applications on our phones, comparing the men with whom we occasionally chat.

This activity goes on for hours.

Sometimes one of us leaves the cool air to make a cocktail, and we briefly try to relocate to the breeze of the roof.

Another friend comes, joins us in the bed, also scrolls through boys on his phone.

We laugh at the images on the applications, a queer grid in which the four of us occupy a single row, me and three tired faggots.

An hour or two past midnight we put our phones away.

Simon, Henri, and I fall asleep in the air-conditioned hum, each curled up to the shape of another.

As we leave the next morning, Simon grabs two of the blue-foiled candies and places them in my purse, little shards that will begin to melt in the heat of the subway.

I connect first to Gonzalez-Torres at the point of aesthetics, a string of lights or a photo of a bed made exhilarating.

In part because of this allure, it is possible to forget his political efficacy.

In intention and execution, his work is as driven by motors of dissent as by the mechanisms of beauty—

or rather, the mechanisms of beauty as brilliant dissent.

He spoke of his interest in occupying power, in infecting it, through the billboard, the distribution of objects, the dissemination of information,

those reproductive systems of capitalism.

His work does not simply endure, but rather it replenishes itself, proliferating freedom, grace, and change.

It is a thing that can be taken from and put back together to be taken from again.

Like so many of my friends, I found my way to this city because of what it had been.

What it had been, we thought, meant what we could be.

I walk up to the pile of candies.

I take one for myself.

This candy is free and it is mine.

I think of Ross in L.A., and of how truly little we might transport from the past, when we find ourselves at this point that feels like connection.

I am aware that I take something away.

I am not certain, however, of what I contribute.

There is a critic in the city whose writing I came across a year or so ago.

While in Lefferts Gardens, I email him—

Hello, I like your work—

and he accepts the offer to have drinks on my roof an evening while Simon is out of town.

The night of, I put on a see-through gray T-shirt, and use a Q-tip to make perfect lines of my red lipstick.

We laugh, talk about books some, and after he asks to kiss me, we head downstairs.

When he leaves, I have the bed to myself, which I rarely do.

Although we text back and forth, he declines my offer to have another date.

I futz away my evenings on other boys, my nights veering toward more immediate pleasures, my makeup always smeared by sunrise.

My lingering attraction to the critic, I tell myself, has to do with his words as well as his body.

I want to inhabit, alongside him, the space he writes,

think my way apart from what I know.

I joke with my friends,

"The critic has broken up with me already,"

and we decide, as you are allowed to mourn a relationship for half the length of time it lasted, that I can take three hours at the bar for this.

I experienced the act of removing the piece of candy, with its overt ritualization, as an act that both grounded me and pushed me further into an imaginative space.
The tactility of unwrapping the paper and tasting the melting sugar situated me in my body, while the fact of Gonzalez-Torres's romance with Ross removed me from my experience.
I know, however, that I was only in my own memories.
My losses are squarely different than his,
as none of our losses are the same.
His work moves between fact and imagination, the object and the memory, to open a new space:
from me, to something that exists beyond that limit.
Like I was only a boundary before, and now I can move again— pushing through a crowd until I come out the other side, and the air opens up and I breathe.

My roommates and I hold a small party on our roof.
The critic, invited, does not come.
I spend the night smoking cigarettes with a handful of friends I have dated or am still ambiguously dating, all of us clustering in a corner with less roofing tar than the others.
To chart these romances would be to name constellations among stars that will not stay still.
At one point, a friend laughs,
"I want one of those damn candies but I guess some important artist made them,"
before taking a candy.
There is Another Trans Poet at the party, a stranger to me.

He does not match the enthusiasm of the conversation I offer
to him, and we reference only a few favorite writers before he
returns to his date.

Later, I won't remember the conversations I had, just that an
old friend comes up behind me and holds me, their arms a
firm pressure against my chest,

and that, when the moon first peeks above the geometry of
Lefferts Gardens, a guy in purple makeup is surprised to see it
so low, insisting that

"it is always higher,"

despite agreeing that it rises and sets.

What can one do with a past?

What I mean is, what can we do with our bodies?

I want a white-walled room, a bed with white sheets, a lamp
and a pile of books,

as my emotions linger on what I have not experienced, on two
men together, and how that must feel.

With the heat in Brooklyn there was nowhere for my friends
and I to be but beside one another in this bed.

The night seems hotter when there are more people gathered
together,

hotter though the sun goes down, and the city's dim lights
turn the streets silver beneath us.

I am still uncertain whether these are the experiences I had
hoped to find,

just as I can't tell whether I am conforming to fill a shape or
drawing its boundaries.

I leave the party on the roof while it continues, everyone
leaning in closer together, some queens showing up late and
passing me on the stairs.

I come and lie beside Simon.

He and this bed are two things that I know.

They are familiar.

We are so boring, we laugh as we talk in and out of our sleep, the party's buzz above us.

We both prefer an empty room and glass when it breaks.

I felt then that I was beginning to navigate some of that desire for Simon, which was a quality of loss, as I understand all desire, or rather, all the desire I have known—that my want for another body arrived, first, with the knowledge that it could not be. Maybe this is what binds the family of men together? The desire for the top and the lack of a top, a torque of specificity and hope.

But on this bus moving south, I think of what is not written, the silenced past and the terrifying future that weigh on autobiography. I can't account for most of what happens, my own life getting in the way of it. My dear friend Sterling died from complications due to AIDS one year ago. He was still alive when I started writing about Simon and Felix Gonzalez-Torres, so I can't reasonably make sense of his absence in the story, although it still frustrates me that the writing doesn't. There are many little absent moments as well—walking with Simon to get more beer from a bodega when we first met, I bonded with him over our obsession with ice in the moment it breaks. He used to take photographs of it, he told me. I write about it, I told him. I described my obsessive chronicling, trying to write ice as it is, purely there. We talked of the difference between desiring ice in the moment of its break, or desiring ice in the moment before the crack, or after. I didn't put any of this in the essay, either—what the ice means to Simon, its metaphors, none of it being mine to share.

I arrive in New York City late, take a quick nap, and, as the sun rises the second time (its rise over the building horizon), I transfer to another bus, continuing south. This is the start of an open summer, a couple thousand dollars I've saved from a free-lance gig and a two-year visiting position teaching at a college in Chicago that is waiting for me in the fall, so I'm trying to be optimistic. I occasionally read a poem or two in *Wanting in Arabic,* but mainly I sleep in the back seats and try not to think about peeing. As I am literally moving away from Simon, I do some visioning of what my next relationship will be (open in the ways Simon was unavailable; romantic; transsexual) and I cast intentions, projecting this openness toward the universe as a spectrum announces itself unto the heavens. I think of the love I have within myself and in thinking of it make it an offering to the many-handed hunger of transsexuality. I try to become aware of the movement of my body, which feigns stillness while crossing an earth that spins and arcs, and in that collapse of motion I sense the impossible movement of love's potential, an ecstatic spatiality. I become through this meditation more than myself, physically, and so I find a way to move directly through the possibility of Simon and into simple possibility. I drink Gatorade, many different Gatorades, over the long ride. When I reach the rural mountain holler where I used to live, I pee wildly beside a barn, and fall asleep on a friend's couch that smells of tobacco and the damp summer ahead.

When I'm in the woods I always feel a bit crisper, as though I experience myself more here than I experience myself when I am in a city. My body becomes social with the bodies of trees and of the creek, and the bodies of all the living and dead things, its strangeness comfortable and good.

It has been a year since I moved away from this place, where I lived the longest as an adult. A short fling brought me here, a hookup telling me about a farm where his friends, mainly trans people, were growing food and teaching each other carpentry—an escape, as I wanted to flee and to become something else again. There are actually rural pockets like this all over the country, of weird people, come to find out, doing all sorts of odd things in places you wouldn't expect. When I learned that this was true, I was excited by the possibility of living as I wanted outside a city, what with cities seeming like this kind of queer inevitability, necessary if I wanted to fuck and dress weird. It was also the recession, and while I had gotten by for a few years with a grad school stipend, like the undergraduate scholarship that I used to leave my hometown, I wasn't earning enough to cover my bills, let alone my debts. Living rurally was cheap, and it meant that the job I picked up fencing at a goat farm, along with the money I made writing things for people off Craigslist, was enough to pay my bills for a while. At the time I thought: *building things,* and *growing things,* and *hammer,* and *tomatoes.* It was only a year or so, however, before learning how to swing a hammer let me think *I am the one who makes my body different* and before I knelt in dirt and placed my hands on rock and decided to start dropping little blue pills underneath my tongue when I woke, to take more control over my future body.

This desire to farm, to build and grow, has something to do with a generational obsession with the coming end, when the machines of capitalism and nation will inevitably fail. I made the decision to live rurally shortly after protesting the Republican National Convention in St. Paul, when I first saw the hooves of a police horse land on the legs of a protestor. As police raided the

homes of organizers and activists, the convention catalyzed my politics, orienting me toward legacies of direct action. Sitting on my roof in the Midwest after the RNC, smoking with my friend Torrey, our conversation darted between her life in the world of cross-dressers and mine in queer anarchy. We were two friends everyone knew to be boys and who knew one another better than that, and on the roof I could think of very little other than the course of humanity, eating us dead.

Torrey lived outside the queer enclaves I had carefully inhabited— queer brunches, guerrilla queer bars, queer road trips and music festivals and bookstores. I was envious of this difference, a difference that held our conversation to honesty. She had short blond hair and no makeup as she offered her perspective, that perhaps the world was not about to end, but had already been ending, violently and again and again violently once more. I was born in 1983, and heard for the first decade of my life no mention of queerness outside of the context of hate and epidemic. As media representation and legal protections grew in the following years, so too did a queer cultural anxiety around political collapse, and a gnawing awareness that those protections were flimsy, insufficient at best. Washing endless piles of dishes with Food Not Bombs, or organizing a misguided action at a Bash Back! meeting, I resisted the mainstreaming of queerness, as it seemed urgent to sustain a more radical tradition, assimilation being a form of death. I still know that the liberal state is a trap, and capitalism a death drive, but back then, as I pointed toward climate change, peak oil, and the escalating "War on Terror," I thought I was pointing toward an inevitable future catastrophe. In fact, I was just facing the ongoing catastrophes of history, and still living in the intractable world of my youth.

People tend to remember the starts and the ends of things. Although my move to the foothills here came with a sort of naive, dystopian concern, my move elsewhere five years later was more about committing to romance than it was about committing to a politic. My last night, Simon visiting from Brooklyn, he and I fucked on the side of the hill until a friend came across us—"Clutch was ready to ride that dick," although I was actually face-fucking him, knees beneath his armpits and my hands holding his head steady. The next morning, we put boxes in a rental car and drove off, planning to go first to my mother's home in Michigan, and then into a future somewhere, unspecified but for the fact we would be together. This would prove to be Brooklyn and then Seattle, and finally, abruptly, apart after we found ourselves unfucking and underemployed in the view of Mount Tacoma, an eight-month coda to something like friendship.

Despite this year having passed since I moved away, I am pleased to discover on my return that I wake just after the sunrise, as though hearing the creek beside the shack I built recalls from my sleep that the chickens might need releasing from their own house, too.

I smoke a cigarette even though I said I'd quit. I spend some time with the creek, knees down and everything trickling. It splits outside my old shack, each direction framed by the Appalachians, their steep hills the one way and their flat rock walls the other—a new creek, I guess. It's a dry creek, as the water runs beneath the rocks, and, when it rains enough, it rises, and there are tiny fishes. Part of a long series of creeks across the rim, basin, and plateau here, that made the land rich hunting ground for a number of tribes over the centuries. Settlers first arrived here around 1795, following a military expedition the United States launched

against the Cherokee who had taken up resistance in the region. A mill built around 1800, a ten-minute walk from my shack, anchored a small community of settlers, and people soon built their homes down the hollers, with the poorer white families and enslaved people in the back and the wealthier, slave-holding families out in the valley. The mill is still there, although it doesn't work, and near my shack two of the poorer families' barns stand after more than a century, each tilting. The plateau where I used to live and the mountains in general are eroding, smaller than they used to be, but they still hold large expanses of uninterrupted forest, where the creeks lead to more creeks.

When I walk to an outdoor sink the first person I see is Jackson. He is Australian and visiting my friends here for the summer. I first met him three autumns ago when he passed through the States, and while we barely talked he remained sharp in my mind. "Hi, we've met before, I'm Clutch," and "I remember." As we talk, I am acutely aware that I have not yet had time to shave. I notice the thin mustache above Jackson's lip, which is soft (the lip), and insist on thinking, persistently, about the fact that I have not shaved. He tells me that it's his birth- day and he invites me to a gang bang on a pontoon on a lake nearby, where our friends will be fucking him. He is short, with short hair and a slight mustache and the kind of tat- toos that make you look like a desk in a math class that has been scribbled on, and he is incredibly handsome. I decline, so tired, not having shaved, and when he leaves I immediately regret it and feel I have left again that version of him who had stayed in my mind so sharply. Later, a year after we started what I thought was a fling, which is to say the day of his next birthday, I write a little poem about this moment for him as a birthday gift.

The gray slats of wood that are six inches or so by eight feet or
so by half an inch or so.

 I know the sink inside and think
of how I need to shave and behind you are tools against an old
single-paned window, purple-painted wood.

I did not know this was happening for some time.
You are something like where I find you,
where I can't do the same thing again even if I try.
Even if I try to do the same thing,
 anymore than a tree,
 anymore than you.
Anymore than when I met you, and then I met you again.

I say good-bye to Jackson—"Sorry, no gang bang for me today,
see you later"—hold a hot washcloth to my face, and go on a
short hike to circle the land and revisit its plants. There are little
bugs, the kind I can't stand, but it is a gorgeous day of sunshine
and shade.

Up creek I find a dead baby possum, lying on the trodden grass
of a pathway, too young and pink and embryonic to be out of
its mother's pouch. Its eyes are such pale gray slits that they
seem neither open nor closed. I stare and try to understand.
Then, a few feet away, I find another pink abandoned baby, this
one somehow still alive. It has the heavy arrhythmic breath of
a dying mammal, taking in gasps that don't carry oxygen, with
no noticeable exhale before the next sharp breath in.

Searching farther, I eventually find seven abandoned babies,
five dead and two alive. They are scattered in a zigzag path with
roughly two or three feet between one another. I see a friend

who grew up around here and who knows the landscape better than I do, and she helps me track the possums down and confirm that there are no others. We ask each other, are they actually dead possums, or can possums play dead even when they are that young? Searching the brush for ten or fifteen minutes, and with nothing else to be done, she takes the babies that are already lifeless and poses them together for a series of photos. I take a rock and bash in the heads of the ones that are living, knowing that a quick ending is better than their extended, laborious breathing in Tennessee summer heat. The gashed head of one is too gruesome for the photo, but the other maintains its peaceful stare despite its blood leak. Like six old men in the clover, pink and still. We dig a small hole and bury the family together.

When possums first crawl toward the pouch they are only the size of a bean, and many fail to attach to a teat or secure themselves inside, falling off instead and often forgotten. The mother possum had made that crawl when she was young, too, and then made whatever possum life that followed, which I'm sure wasn't easy. Is this what it takes to live sometimes? Digging into a pouch, tossing, rummaging, tossing, and running? Leaving what you love, three feet apart? Our own nature can pull us so easily to a horror like this, to throwing to the ground as we flee who we were. It seems unrecognizable to that other sense of nature, the pucker-hugs of cloverleaves over cloverleaves and grass and dirt beneath, but I guess each is a way to live and make more life.

My friend tells me that the possums are just dead because we're in the woods and things have to die, and we walk to her house so she can email me a copy of the image. The woods do seem to toss the dead at my feet. This is a steady thing, seasonal even,

unlike the deaths of people in my life, which are more and more every year, always. It took me a while to accept this, that the deaths were not singular, but the toll of capitalism and hate, which accrues. Knowing the movements of the crayfish under the rocks, their burrows where they gnaw decaying wood—this is calming, that each one of them is going to die, too, and then there will be more crayfish there, at least until there aren't.

I hope to see Jackson while daylight remains. The height of the hills means darkness falls first in an early shadow, and then fully, as I ride my bike to where I think he will be. When I do find him it's at the start of an orgy on an old school bus my friend converted into a home. Aligning our bodies across bodies, reaching and joining, we immediately begin fucking, becoming just the two of us, an orgy of two that lasts for days. Our union is a further splitting open of time, in the way erotic time is composed of infinite moments. It moves me forward like da Vinci's Vitruvian man stays still. We fuck in barns and yards and the backs of trucks, into the night and morning both. I barely see the friends I came to visit. We fuck in the afternoon after napping, and I wake him by first gently kissing his tits, then shoving a Snickers ice cream bar into his mouth and fucking him again. We decide that we love each other. We lie in the sun. We smoke cigarettes. We fuck so much that when we realize we are both headed to New York for the summer, we change our flights so we can fly together and fuck on the airplane.

Between all of that, we still find plenty of time to talk, the exhaustion in our bodies giving way to loose, quick conversations, the kind that makes it easy to feel like you're getting to know someone.

"There are people setting up human composting in Seattle," Jackson tells me.

"I heard about that when I lived there. Like figuring out how to set it up."

"Why can't you just put a body anywhere? The earth isn't hurt by bodies."

"Tennessee is one of the only places in the States where you can arrange to be buried at home, if you own the property," I offer. "I don't know why you can't just put ashes anywhere, though. Or maybe you can."

"Was it Calvin who was doing something like that?"

"Like an art garden for burying people. In Seattle?"

"Wouldn't it have to be here?"

"I don't know."

"For my birthday in Seattle one year Rizzo gave me thirty seconds in a candy shop and however much candy I could grab, she bought me."

I laugh. "What kind of candy did you grab?"

The day of our flight, I wear a short romper with no underwear to make it easier to fuck on the plane, and we put our things in bags and hold hands. Backtracking the path, I find another

scattering of baby possums—although this time, weirdly, they are older, with gray fur, so that I might have thought they could survive were they not already at death, unable to crawl or stay still, twitching. Rocks to the heads again, but something about the older age or the repetition of event made a photo seem unkind. Instead, I set them one at a time in the creek, where they float off like loosened lilies.

I always know there is going to be some bullshit at the airport. On the ride there I breathe and prepare myself for a combination of touch, inspection, and exposure, rehearsed to the specifics of my body. This time what happens is that I lift my hands above my head into a triangle in the whoosh machine and my romper rises too and my balls peek loose, and then I'm done. I laugh about it and hold my bag closer for a while. At a layover, I sip from the fountain, skipping anything more so I won't have to pee, and text my housemate in Lefferts Gardens to say I am bringing my new boyfriend home with me for the summer. "That's great, how long have you been dating?" Ben asks. I reply, "Two weeks," and get another affirmation: "That's great, fabulous! Love it!"

One disappointment about summer is that there is less ice during it. When I used to keep my daily practice of describing ice in prose, I would refrain as much as possible from writing of anything but the ice, not only avoiding the qualities of the rocks that abut it, for instance, but also remaining focused enough to avoid describing shapes when possible, or edges. Tedious and repetitious, I almost always went wide and failed the game, although the practice came with some ease in the winters, for the dull fact that there was ice around me. Getting close to ice made it easier to get my prose close to ice, and in turn the

summers, glaring and sweaty, had a sheen distinct from that gradient white.

I get my old bedroom, which before it was mine, was mine and Simon's, and before it was mine and Simon's, was just Simon's. The funny thing, I've noticed in cities, is that people don't seem to think much about who has been in the apartments before them, although that has usually been so many people. I found my way to this apartment not because Simon lived here, anyway, but because of the inane rules of acquiring hormones. There were only a few places, at the time, that would give me a prescription for estrogen and testosterone blockers without my "living as a woman" or some bullshit for a year, talking to a therapist and so on—I'm not going to go to all of this trouble just to pretend to be a different thing that I'm not. That wouldn't make any sense. There was a women's clinic in Atlanta that worked off the informed consent model I needed, but when I called, they told me they provided services only for transgender men (what?) and wouldn't be able to help me. That left Philadelphia, Chicago, and New York as my closest options. I considered just buying an irregular supply of hormones through "the internet" or "friends," but having followed a lady I had a summer fling with to Brooklyn and formed some connections there, I made the commitment to visit New York every six months for the next few years, taking a bus or catching a Craigslist ride up the coast and getting my blood drawn at a place named after Michael Callen and Audre Lorde.

Another way I'm of my generation, fleeing the suburbs and small towns of Middle America for its coastal cities around the turn of the twenty-first century. There is maybe an optimistic streak in there, that promise of the queer horizon elsewhere—not a

way to live where you are, but a you who can live only some-
where else. And there is maybe something joyous in that
flight, even though it so often begins in terror, from the epi-
demics of sexual violence and suicide and silence that live
in this country's hometowns—something joyous in survival.
Still, many of us, especially the people of privilege, made that
flight ill-equipped to live in the cities, ignorant of where we now
were, and ignoring the violence and displacement that arrived
with us. Hurt people can justify the hurt they cause so eas-
ily, sometimes, calling it necessary, feeling it is survival. It's a
thing that must be accounted for, to earn the optimism back,
although it seems nothing short of the ocean rising up and
swallowing the coastal cities will make the liberal transplants
of my generation turn back home and face what lives where
we were born.

All that is to say, whatever my connection to New York might
be, it was at first one of temporary commitment, an attempt to
access a kinder bureaucracy. I wouldn't want to add my voice
to the voices of those who seek to describe New York in any
substantive way. But it did also form me. I fell in love here, for
example, twice.

Jackson and I, unpacked and rested, young and in love and in
New York, decide that we would like to collaborate on a proj-
ect, and so we begin a search for the gay men's cruising spots
of yore. We begin it by smoking cigarettes on the roof, looking
over the buildings, and talking about what we know, and then we
begin it again by walking down four flights of stairs and out into
the city. Jackson is animated, the way he gestures with his right
hand, and he always makes me laugh. We are both interested in

the things that we came too late for, which means we're going to have to do them ourselves. I talk about Samuel Delany, chattering on about how he loves dirty, bit fingernails and about *Times Square Red, Times Square Blue,* where he describes the shuttering of porn theaters in Manhattan as a blow to gay culture, setting liberation back decades. Although I am not queer these days, I know the queer contours of New York better than Jackson, having picked up plenty of subway strangers here when I was younger. I used to be especially talented at it on the L train in Brooklyn, although I stopped when my tits became obvious enough to overly complicate my connection to fag sexuality. I sought the hookup for its straightforward, just-the-dicks-ma'am nature, which seemed beyond grasp when the last guy I picked up, a drag queen on his way home with a wig box, said, "So you have breasts *and* you're a top? Tell me about that." It's what I learned with my old body, then, that leads Jackson and I on this search for something we know isn't there.

My copy of *Times Square Red, Times Square Blue* has my friend Cyd's inscription in the front, written to and flirting with our shared friend, to whom the book actually belongs. Cyd and I have been hooking up for about a decade, quick sex the once or twice a year we're in the same city, which means he's been a constant through the relationships of my adult life—tick, and then quite a while later, tock. I have a lot of these people in my life who I have sex with when I see them, which is sometimes, although always there is the possibility that when you see that person the next time you will not hook up, so every time might be the last time. People who are or were like this are most of my closest friends. I first began hooking up with Cyd the summer I always wore a fake pearl necklace wrapped thrice as a bracelet,

until one day while I was fisting him he pulled on the bracelet-necklace and it burst, fake pearls everywhere.

Looking back, I appreciate this scattering because it helps me think of the pearls more directly, to engage with them non-metaphorically, which is good, because I've been getting bored with metaphors anyway. I've decided that I don't like them because one thing is never another thing, and it's a lie to say something is anything but itself; it's ontologically and physically impossible, in fact, not even *apple* and *apple* can be each other. So the gay men sexual walking tour of Manhattan has this additional challenge, that I must avoid metaphors even as I seek to experience an echo of the city's past.

It is lots of walking, and I am usually in tattered T-shirts that show my tits and Jackson is often in track pants and pornographic shirts he embroiders that show his tits. *1-800 Eat Pussy No Sleep Rave Nation,* one of his shirts says. One day, when he's off on a date, I go for a walk by myself. I wear a torn, floral dress, similar to something Janeane Garofalo would have worn maybe in *Reality Bites.* I smoke a cigarette even though I said I'd quit. It is very hot. I am late for where I'm going, which is to my friend Avory's house for takeout. Avory is very good at hosting, asking questions and talking, and always looks put together even when we're just relaxing, so I'm sweaty and hurrying to go relax. I walk quickly to pass this group on the sidewalk, five adults and a kid maybe four years old or so, although I'm bad at figuring out how old children are. As I walk by, the kid turns to me and says, "Hey, are you a girl?" and I smile and I say, "No," and then the kid says, "Are you a boy?" and I smile and I say, "No," and then the kid seems to think very carefully and says, "So you don't have to be a boy or a girl?" and I say, "That's right, you got

it, you don't," and I smile again but start walking even more quickly because there are five adults with this kid and a lot of adults don't want you to tell their kid to be a transsexual.

What matters though is that as I am walking ahead more quickly the kid yells out after me, "Hey! I live in a house with a door!" The kid says it with a lot of confidence and a lot of happiness, really wanting me to know this. And I turn around and say, "Hey, me too!" and we both laugh and then I walk down the block.

Isn't that so beautiful? "Hey, I live in a house with a door." I'm hungry for truth and kids are just spouting facts up and down the street. I tell Avory about it and they immediately understand what the kid is talking about, nodding a lot as we pass a blunt. The next day Jackson's friend from Australia, who is in town performing monologues about sex work, comes to my apartment, and men on the street have just yelled at her. I change course and tell her the story about the kid and start rambling about all this, metaphors, and whatever. She says to me that she actually thinks what the kid said is more beautiful if it isn't metaphor, anyway. I had shared some information about the world and then the kid wanted to share some information about the world, and if I get all loopidy-loo about what the kid said, I'm probably missing the whole message, which is just, "Hey, I live in a house with a door." And really, she reminds me, isn't some information about being alive beautiful enough? That we dry forks and touch hair and throw away a sock?

That night, some friends and I take a taxi to this party where there is a whirlpool and the taxi driver lets us smoke in the back. It's a party I always avoid because only gay boys invite me so I assume it's a gay boy party, and I know the drinks are expensive

even for a Manhattan party on a roof with a pool, and the only trans person I ever see in photos from this event is Amanda Lepore. But this week enough of my friends are going to make it a party I want to go to, too, and anyway, Amanda Lepore always arrives before me—on a daytime talk show in the small town where I grew up, a voyeur looking like an ornament.

An elevator lady takes us up to the bar where the space is a big crowded square. I do enjoy this party because I quickly start to lift abandoned drinks off tables and dance in the whirlpool, which comes to my shoulders, so I dance in slow motion (the water) and with displaced movements (jets hitting my legs and arms). I start to hook up with a friend in the water and Jackson is in the water, too, and he starts to hook up with someone and eventually we take a taxi home and have an orgy. At the orgy I touch my hair, I go and pee, I feel a nipple hard against my own. My inclination is to say something about a door here, a metaphor of a door, but instead I'll say that when I lick Jackson's thigh his sweat tastes like Jackson's sweat.

Even when I say that the short walk to the train is hell sometimes, or that human connection is a broken and bruised cock, or that a pearl is a thing with feathers, really, wouldn't an even stronger connection have been possible without the fantasy? I think about a walk to the train, I think about human connection, I think about pearls. I think of the door the next evening, too, when I walk home and some guy calls me a faggot, whatever, and it is dark and the cars on my street have those blue security lights flickering in their front windows, on the rearview mirrors, a long row of unsyncopated blue lights. And years ago, pretending to be a young boy, I would have seen this and called it eidolon breathing or a calm like the calm of the stars

also flickering above, but it's really just a bunch of lights and I know now that they say, *This is my car, don't fuck with me, I'll call the police and they will hurt you, I have something you don't and I want to keep it that way.*

Jackson and I do a lot of going places, looking for somewhere to pee, and then deciding to go somewhere else. We go to that room that used to be a bathroom with a bunch of pornographic Keith Haring figures on the walls and with all the toilets and everything yanked out. I push him against the wall and kiss him and we start to have sex but I chicken out. The next day he and I sleep late, then go into Manhattan, hoping to find a porn theater that I know won't be there, but finding ourselves instead at Mmuseumm, a tiny museum in an alley, one of those Manhattan alleys in crime movies of the 1970s and '80s that don't seem to actually exist. We're always looking for somewhere to eat and then eating pizza out of the trash. I think of Simon sometimes, and how we did these types of things, and even these very same things. Simon showed me a good pizza trash can, for example, at Fourteenth and First. And Simon and I jogged around Prospect Park, where Jackson and I fuck in the morning if we've been out late enough. Simon would slow his pace for me until I urged him to go ahead, and then he would wait for me, happy, back where we started, until I arrived in my own time.

For six months or so, Simon attempts to give me a copy of an ice book he likes,
picked up at the used bookstore where some of our friends work. He visits me often, as I visit him, and he repeats the intention each time.
"I keep meaning to get you a copy of that book,"

he tells me.

When I go to see him in Brooklyn, it is beside his bed, recently read, although I do not pick it up.

The Ice Museum is a lyric-sheened narrative about Thule, the mythical, northern land first mentioned by the ancient Greek Pytheas, who wrote of visiting it in a book lost to time, *The Description of the Ocean.*

Thule is like Atlantis but crusted with ice, and, instead of sinking,

its imagined location just becomes farther and farther away when explorers cannot find it,

drawing them north each time, to somewhere colder.

The people in Thule were giants, or the people in Thule were miserable, and they lived off root vegetables and herbs, where night or day could each last for months.

Explorers kept pushing toward the Arctic, seeking the Thule that Pytheas described, its imagined location in Norway, Iceland, Ireland, Estonia—always elsewhere.

Over centuries of poetry, song, and myth, Thule became a European dream of a utopic beyond, metaphor overtaking geography.

The book is calming, Simon tells me,

its rolling descriptions of snow, waves, and moss.

And although we are sincere, he in his intention to buy me a copy and I in my intention to read it, I read only the first lines, in which

"the ice sounds a ceaseless warning."

He comes to Tennessee, his own copy in his backpack,

and I return to Brooklyn, where it sits between two volumes of Proust on the bookshelf headboard we installed together behind his pillows.

When I stare at the white wall of Simon's room I imagine those masses, those deep-throated moans of ice, inching and wind-bit in a place I might never go.

Beauty is a source of strength—

I can become my best self when facing beauty, in awe of what I can't possess, can't fix in language, can't know.

It is in wonder at the image of an iceberg that I confront its collapse, its warming away.

An iceberg is pretty, too, and brilliant, radiant, but these are the physical qualities, and beauty extends beyond whatever object it inhabits.

It refuses to diminish itself to the terms of our petty desire, yet forces our compassion, makes us realize we are sharing something.

I know my love of the ice as aesthetic object first and political object second is inadequate, yes,

but I hope beauty might still touch my humanity, the part of me that is shared, that is awful and good.

Simon comes to Tennessee, I catch a Craigslist ride to Brooklyn, and Simon comes to Tennessee again.

It is winter, and a waterfall, an hour's hike down the creek away from my house, has frozen.

A waterfall freezes while the water still flows, so first there is a drop-off of ice, hidden at the top of the trickle.

And then more of the creek trickles down, and freezes also, becoming a column, incrementally bigger, the flow stilled at its edge.

Over many days of this, the fall becomes larger than it ever is when its water runs fast in the warmth of other seasons.

And the ice, accruing in all directions, appears as a permanent froth and rage,

suggestive of movement, yet calm,

great ice waves formed hard at earth.

When Simon and I come upon it, we linger for a while, and throw slate into a hole gaping open at its base.

Our hurled objects disappear behind the white rim and we cannot see them land,

can hear only the slow trickle of more water dripping and the plop of solid into liquid.

We both worry that the sculpture will shatter, a vision we hope to see.

By the medieval era, several places had been reached, each named Thule, and each determined to not, in fact, be Thule. Cartographers began to indicate ultima Thule to clarify this. This ultima was the Thule that had not been discovered, the Thule that explorers hadn't reached and that needed to be distinguished from the Thules they had found and that they still wanted to write on the map.

The Thules and Thilas and Thulas of the frozen coasts—

real places with bearded men and dinners of fish and fermented liquids—

their names mark them as less, their movement from the exaltation of what could be and into the tired reality of what is.

Simon explains this all to me as we lie in bed, having both woken early and at the same time.

He returned last night from Maine, visiting a gay bar where the men had salt on their faces while I stayed behind, reading and smoking cigarettes on his roof.

These are some of my favorite moments, when one of us has gone somewhere else, and then we come back to each other.

I close my eyes, thinking I might fall back asleep soon, and
letting Simon's voice fill the map of my imagination while
I do.

That billboard of the unmade bed, those two pillow dimples
from two heads—
an installation at Brighton Beach, Berlin, Paris.
Spotlights on a corner,
as any two people in love might be.

In 1990, walking around Los Angeles, Felix Gonzalez-Torres
and Ross came upon *Gold Field* in a gallery.
A work by Roni Horn, it is a rectangle of forty-nine by sixty
inches, two pounds of pure gold pressed so thin that it rises
barely above one-hundredth of a millimeter.
Horn's intention with the piece was to allow viewers to appre-
ciate and respond to the gold absent the economic, political,
and social histories that suffuse the material.
Knowing that Ross was approaching death, the couple came
across the flat gold, and, in the artist's words,
"There it was, in a white room, all by itself, it didn't need com-
pany, it didn't need anything.
Sitting on the floor, ever so lightly.
A new landscape, a possible horizon, a place of rest and abso-
lute beauty . . .
Ross and I were lifted.
That gesture was all we needed to rest, to think about the
possibility of change.
This showed the innate ability of an artist proposing to make
this place a better place.
How truly revolutionary."

The revolutionary potential in Horn's flat gold is not in contrast to her desire to extract the metal from those political histories,
but rather it is an accomplice to it, a transcendence.
Where the gold sends you, I think,
is to a better version of the world you are in,
with a golden light to it.
Gonzalez-Torres and Ross continued, briefly, to live in Los Angeles,
the city being the only place they cohabited, with Ross dying about six months later.
After encountering the piece, they called every sunset they saw "the Gold Field,"
Horn having, as Gonzalez-Torres said,
"named something that had always been there."

Simon and I, hiking back from the waterfall, commit to visit Iceland and Greenland together.
He will take photographs of the ice, and I will write of it,
we decide, although how we think we will pay for this trip, we don't say.
"You need that space, you need that lifting up, you need that traveling in your mind that love brings, transgressing the limits of your body and your imagination,"
Gonzalez-Torres said, explaining the import of love to art.
Which is true, although it is not clear to me, what it is that I am imagining Simon and I are together, when I am imagining we are together,
somewhere else.
I say,
"You know that I'm talking about you when I talk about the ice,"

and he assures me that he understands, which I accept,
although this is the most directly we have spoken of ourselves
to date.
On this hike, we often must decide if we will step on a thin
sheet of ice, which might break and release us into the cold
and shallow creek water,
or slip across the ice-slicked shale and limestone.
Sometimes Simon reaches out and grabs my arm, so I don't fall,
and when one of us does slip, we each break into laughter,
happy with the sun shining gray, or maybe silver, through the
bare branches of the trees.

But no matter how far away you manage to get, still you will
find yourself there.
The northernmost base of the United States Air Force is the
Thule Air Base, in Greenland, 750 miles north of the Arctic
Circle's boundary,
its location decided by the u.s. and the Kingdom of Denmark.
Its closest neighboring village, across sixty-five miles of ice and
stone, is Qaanaaq,
home to the Inughuit population who were forcibly displaced
north when the base came;
in 1951, a group of hunters returned from an expedition to
find the American military there, raising buildings and pre-
paring for a potential nuclear escalation in the Korean War.
The Thule Air Base today fulfills a few functions, primarily
keeping watch for (and potentially shooting down) inter-
continental ballistic missiles headed to the United States,
its location being halfway between Moscow and Washington,
while assisting with the Global Positioning System, perform-
ing satellite surveillance, and housing advanced weapons,
among whatever other secrets conspire there.

It is where, in 1968, a subsonic bomber crashed into ice, damaging and nearly detonating four hydrogen bombs.

One bomb was lost forever, its twelve kilograms of plutonium dispersed in the ecosystem, where furless seals now sometimes roll on the glaciers.

What a pair—

that imagined perfect ice, so much of it that Simon's imagistic obsession and mine, twinned, might be united there,

and our militarized state, with its enduring aggressions, ensuring that the ice will melt.

This is not a Thule imagined, not the place Christopher Columbus claimed to have seen, but one made,

built on ruins over six centuries old, as soldiers communicate with far-flung satellites and missiles.

It's a place that is often accessible only by aircraft, where not a single road leads.

It's on a map, so even if you can't go there, still, you can find it.

Is beauty panacean, able always to instill in us moments of transcendence?

Or does the sun just melt the ice,

beauty appreciated only when it is the constituent hum of a thing that fades?

"When people ask me,
'Who is your public?'
I say honestly, without skipping a beat,
'Ross.'
The public was Ross,"
Gonzalez-Torres asserted.

And really, no matter how public the art, the speech act, no matter how many people are gathered around the table, aren't we at our core just speaking to one person?
If today I spoke with one person,
and if we both heard one another,
there might be enough value in that.
It might even make things better, or start to change something that needs to change, if we both rest, and pay attention to one another.
Yet when pressed on his statement, asked later if his ideal audience of Ross meant that he didn't care about the public, Gonzalez-Torres clarified:
"You know, I've said that sometimes as a joke, sometimes seriously. . . ."
So yes, of course, both:
a thing conceived to be so confidential and amatory that only one person can be in mind,
and then given again and again to someone else.
Because there are no limits to how much we can give each other, when we recognize that none of this was ever ours to give, and as we give each other the world.

Gold Field initiated a collaborative friendship between Gonzalez-Torres and Horn.
First came a private gift, a square of gold foil sent from her to him, after the two met in 1993.
Then, gifts that were shared with everyone—
by Gonzalez-Torres, a spread of gold-foiled candy and a curtain of golden beads.
Horn returned to *Gold Field* later, but this time making two sheets.

As Gonzalez-Torres described it,

"Two, a number of companionship, of doubled pleasure, a pair, a couple, one on top of the other.

Mirroring and emanating light.

When Roni showed me this new work she said 'there is sweat in-between.'"

The gold candy, made shortly after their meeting, he called *"Untitled" (Placebo—Landscape for Roni).*

It was an endless supply, the size and shape of which would vary from gallery to gallery, depending on the space being filled.

The candy works had what Gonzalez-Torres called an "ideal weight."

Among them, this gold candy was the heaviest, at twelve hundred pounds—

a similar piece from 1991, also called "Placebo," but with silver wrappers, comes in a close second,

while the other candy piles are at most a fraction of that weight, typically either the weight of Ross, or of the two of them together.

It is quite big, after all, the way that a placebo does not work— but also, by virtue of hope, or perhaps imagination, sometimes does.

Roni Horn began to visit Iceland regularly years before this, in 1975.

"Having gone there, there evolved a relationship that I couldn't separate myself from,"

she explained.

"Any place you're going to stand in, in any given moment, is a complement to the rest of the world, historically and empirically."

As I discuss the trip north with Simon, to Horn's Iceland and the Thule of Greenland, I decide to keep these fantasies to myself.
Instead, I show him how thin the gold is,
which is nice,
he says.

Simon and I still talk about going on vacations sometimes, usually about me going to visit him in Arizona, where he grew up, or him meeting me where I am. We used to mainly talk about going places we hadn't been but now we talk about going where we are. One thing is that now if I go to Iceland, I'm going to Iceland without Simon. I am denied, and have denied myself, any possibility of touching the ice of Iceland (where yes, I know there's not that much ice), or of there contemplating Roni Horn, without these experiences being formed in relation to a lack of Simon, as so many things seem to locate themselves in lack.

I've had the same stuffed animal since I was a child, and I have him here in Brooklyn, sometimes tucking him up in Jackson's arms when I wake early and leave bed. He travels with me and his name is Bow Wow. What happened was my great-grandmother gave me a stuffed dog, which I named Bow Wow. Then, after she died, my grandmother gave me another stuffed dog, the Bow Wow we love today. Because there was already a Bow Wow, I named this new Bow Wow "Bow Wow 1." I was then given another stuffed dog, by another old woman, and I named him "Bow Wow 2." With Bow Wow 2 on board, our childhood hijinks (riding spaceships and hiding from goblins in a forest) were a bit crowded, so Bow Wow was retired to the closet. Around high school, I tired of Bow Wow 2, so he, too, was sent

to the closet. When Bow Wow 1 was the only Bow Wow left, we dropped the honorific and he assumed the name Bow Wow, after the original.

Bow Wow has never been sexualized, but the love I feel for Bow Wow, and the pleasure I get from holding Bow Wow, and the comfort of knowing that Bow Wow will be there is a love, pleasure, and comfort not unlike what I used to feel from Simon. One thing about Simon is that, even if we rarely fucked, we almost always held each other in our sleep, and when we didn't, I could just flip my back to him and pull Bow Wow close again. While Bow Wow has never been sexualized, then, he does come very close to sexuality. Holding and being held by Simon could sometimes verge into the sexual, like those early morning moments, waking to touch. Bow Wow is in a weird position now because I have similar feelings for Jackson (who is holding whom, and when), and there is always that question of whether we will fuck or not, a possibility even though it is almost always realized. Bow Wow has been there for all of this, my flipping back and forth between some guy and his stuffed plump, these libidinal undercurrents to it all. It's a lot for the little fellow to take on.

After Jackson makes a little money one night, he and I take first the subway to Harlem, and then a train to a cavernous building on the Hudson River that was once a facility for printing the boxes of Nabisco products but is now a museum of modern and contemporary art. On the way, he reads the essay I wrote in verse about when the critic didn't go on a second date with me and I watch the water and read some of *Mausoleum of Lovers* (the train being fairly empty, or empty enough to read). Inside the museum right away there is a room of Agnes Martin paintings. I first started to like Agnes Martin because of something my friend

Kate said, although I can't remember what that was—all I have left of Kate's impression of Agnes Martin is Agnes Martin's paintings. The painter didn't talk much herself, which is good, that her work is kept a bit removed like that. "When you're with other people, your mind isn't your own," she once said, and although she was talking about perception, and connecting to the realm of feeling, I think about language, too. Can you be alone with language? What a dream that would be, what a nightmare.

Jackson and I don't say anything after entering the Agnes Martin room and we start to walk quickly. I'm surprised that I'm uncomfortable—how silent the Agnes Martin paintings are in the silent room. The loudest thing is probably the resonance of one pink, pale pink, or green past where its color ends, the line a small border but it changes everything, and even this is pretty quiet. I practice not making the silence or the quiet noise into metaphors but letting them be as they are. I can't decide whether this means I should stop or start thinking about the years when Agnes Martin did not paint, so I try to do both to un-either them. One of the paintings is called *Love,* and one is called *Perfect Happiness.* It seems so exacting, to get a straight line like that, off of which to abstract. When we're out of the room I say, "I like Agnes Martin, so does Kate," and Jackson nods, and tells me that he doesn't.

Around one quiet corner are piles of rectangles and circles of felt and copper, and the rough sculptural material makes me think of a construction site, and the absence of other visitors makes that construction site into a cruising ground. I'm too nervous about getting caught to try to initiate anything with Jackson and can't find a way to fake-initiate something without risking the loss of that desire, so I keep it to myself and feel blood rushing. I read on the wall that these piles are supposed to be batteries,

moving and keeping energy, and that for some reason makes the want dissipate anyway. In the downstairs it's again sexy, with Bruce Nauman hallway-tunnels and small televisions displaying our own selves elsewhere situated, but there are too many people here. We both take a large pink sheet with an essay on it. It tells us to press our bodies against a wall and imagine a double of our body pressing back on the other side of the wall, like the wall becomes your body, and it ends by saying this "may become a very erotic exercise." The walk to exit the museum seems to cover more space than the walk into the museum, as though the architecture is requiring me to return to things I have already seen, navigate away from them, and find I have returned to them once more.

I tell Jackson that the essay where the critic doesn't go on a second date with me is part of a book about Felix Gonzalez-Torres, ice, and sex. Its opening line is, "It is spring, and the season of ice has passed." Although I am not writing this book at all, really, lately. What can move it forward if my feet touch his and that's it? Instead what I'm really writing is a love letter to prose, a book that is slutty about it. Like how pleasure, written into the structural, open field of prose, is so lively—the first descriptions of green life and friendship in *Century of Clouds,* a pestle and mortar in *Zami.* When we at last reach the museum exit, the air outside is different than it had been when we entered, rewarding us, so we sit in the meditation and sculptural garden for a bit. We walk to the train when it starts to rain, go back to retrieve Jackson's backpack he had checked and forgotten, and return to the train just after the sky opens into a downpour, soaking the pink sheets we then lay across the backs of empty seats. When they dry they are damaged but we still keep them. I realize as Jackson falls asleep against my arm that fooling around in the

battery room and getting caught and kicked out would have improved this day and the story of this day both.

If the story of one of these days, a day this summer, had a title it might be *"(with dancer),"* or "Take Me Home," or "My Body in a Doorway." I might call one of these days "Gravity," or "Endless Bottoms." A summer like "They Do the Boyfriends in Different Genres," or "Climate Change and the Extra-Estrogenized Body." But anyway, who wants a title? So claustrophobic, when I'd rather just float away in the parenthetical, or jump right in.

There are still some porn shops with cinema booths in Manhattan, even if the theaters are gone, and we can get there without much effort; we just have to take the Q train and then wander. The first time I saw sex was in *Emmanuelle in Space,* which aired on Cinemax late at night in the mid-1990s, and somehow all non-internet porn, including the porn lining the shelves in 2015, seems to have a similar age to the age of *Emmanuelle,* oversized cases with covers where the words are so big they block out the bodies and the bodies are so big they block out the words. The show is a soft-core series where aliens come to observe Earth. The aliens' leader, Haffron, meets a magnificent slut, Emmanuelle, who is described by the opening voice-over as "one of the most sensual and beautiful of all Earthlings." Haffron and his extraterrestrial friends learn about sex from her, finding it both exciting and bewildering, as they don't have sex on their planet, nor have they seen it anywhere else in the whole universe. For the remainder of the series, Haffron and Emmanuelle fuck all over the world, occasionally shape-shifting so they can fuck while inhabiting other bodies, too. I watched *Emmanuelle in Space* toward the end of junior high school, usually with one of the guys in my neighborhood. This

was shortly after premium channels started showing up on our TV, a mistake on the part of a cable installer, I think.

Jackson and I find one East Village sex shop by again hiding from the rain, bouncing first into a corner store for candy, then back through the rain when we spot the porn signage across the street. We go into a cinema booth and I immediately reach my hand down the front of his shorts where he's wet, but a man pulls the curtain back and interrupts us: "One at a time," he scolds. The characters in *Emmanuelle* have this kind of sex, too, where the camera cuts away every few seconds, where penetration is suggested and elided. Watching the show, I also looked and looked away, changed channels and changed back. In most episodes, the cutaways are cuts to the landscapes of the earth or cuts to the aliens, hooked up to virtual headsets and caressing the air. The closest I had come to seeing a visual depiction of sex before this was on a condom box I found at a playground, the instructions inside of which showed a hand and an erect shaft, or something like a shaft. *Emmanuelle* couldn't show this image, which would have been too explicit for Cinemax. Instead, viewers received the landscapes of the earth, sometimes one of those New Yorks that has alleys. That is, I received everywhere that I was not, the places I am now.

Around the time I watched *Emmanuelle,* I was also starting to fool around with guys my age and a bit older. These were moments of convoluted exposure (clothes lost in bets or games), occasionally verging into contact, a friend closing his eyes or touching himself to signal to me. The town was very small, fifteen hundred people or so, nearly everyone white and working class. There was an old abandoned hotel at its center, from when loggers passed through a century ago, and I would sometimes

bring a friend to fool around there, a place that felt both vulnerable and private. When I started high school, the chances to fool around disappeared, the reality and implications of what we did lowering down. Senior year someone lit fire to the hotel. That evening, one of the guys down the road knocked on my window, woke me, and together we watched it burn to the ground.

It is difficult to recall what that total, exhaustive feeling of not knowing feels like now, but it is the feeling I had both in watching the collapse of the hotel and in first wrapping my hand around someone else's cock. Here in summer, slightly stoned in the afternoon and with Jackson beside me, hustled again out of a porn store, his butt and tits a pleasurable distraction, I can convince myself I have learned something about sex over the past twenty years of hooking up with however many hundreds of people. I know, for instance, how to massage with my tongue the muscles of an anus so that it opens itself further, but I still know nothing of why sex, or music, or sunlight hold their pleasures. At its best, in fact, sex seems to be only a movement that draws me close to the intimacy of not knowing: whether I'll slide my cock into Jackson's pussy or his ass, until we find ourselves there, backs arched and fingers tweaking.

I agree with Emmanuelle that the best way to know about sex is to have it. One evening, I go to see the theorist Allucquére Rosanne Stone perform at a conference, where I'm also presenting with my friend Ben on a collaborative project in which we find user reviews of erection drugs online and post them on Twitter as TheCialisReview. It's an exploration of masculinity, wounds, and the digital. The men say things like, "When I do orgasm, I

shoot piss all over the place" and "Failed to ejaculate prematurely" and "I developed a small red patch on the tip of my tongue." These men are so disoriented, as unable to connect with their own experiences as they are lost to themselves in the weird new rules of digital privacy and disclosure. In her performance, Stone tells a long story in which she implants electrodes in a cat's brain and listens to what it experiences as the cat runs through a field, mice in the distance, becoming "more cat" in the process. At its end, she explains that she has remapped the sensuality of her body, placing her clitoris in her palm, and that she gets off on noise. As a warehouse filled with a hundred or so people applauds and cheers, raucous, she then rubs her hands and shakes with an orgasm.

When I say I agree with Emmanuelle that the best way to teach someone about sex is to have it, however, I am speaking from 1995. The summer my house got Cinemax was around the same time I entered puberty. We didn't get access to the internet for several more years, and even then, the available technology meant I could access only written erotica and the occasional photograph. As the town was so small and everyone straight, I had a very slim amount of adolescent sexual knowledge. Searching on Yahoo! after those moments of brief touch that I called sex, I would still not even know what I was looking for, just that I was driven again and again to type in phrases like *bras off*—not exactly pornographic, and vaguely autobiographical.

I think of Emmanuelle like a twin to Amanda Lepore. Appearing through the television, they were each more than the gay men of early *Real World* episodes, more than the lesbian guest stars on *Living Single* or *Murphy Brown*. My young self knew that none of the men or women on television was me, even as

I formed a fractured identification with them—an identification that allowed me to voice a part of myself while negating something more. But still, in the middle of that negation, I saw Emmanuelle. Her body was multiple, exiled from the explicit and made brilliant in the imaginative, both cock and pussy and neither in my mind. And there, in the illogic of orgasm, my body became multiple too.

I don't know what it means to name myself when young, or to search from my mother's living room for bodies in neighboring towns with a tap, tap. But I do know what it means to be unfixed from narrative, an unfixing that feels something like claiming power. I feel grateful for it, really. It meant that I traveled through space as a hotel burned.

My summer in New York City continues to pass the way all my summers in New York City tend to pass, with a pace of hurry, rejoice, and resist. This is off to the bar early, a walk where I sweat and shouldn't have bothered with makeup, people hollering at me, the louder and then less loud hum of the air-conditioning in the window directly behind my bed, not knowing whether I will wait for the bus or walk some, and coming inside from Avory's roof for a Coors. There is fake grass on the roof and I take a picture of Jackson and a friend, then show it to that friend the next day on the gay beach, where I'm naked and then tired and then on a bus. Everything I do is a weird pocket of experience, balanced with other weird pockets, hours spent furiously writing bland text for my freelance gig, the money I saved already gone to tallboys and, when I am too drunk, a taxi. The summer loops back around itself when Jackson and I send a group text to twenty or thirty friends, a picture of us with emoji pills all over it and "Guess who has chlamydia?" written in bubbly letters.

In a run-down building with gay trash everywhere and a performance space, I come late and smoke inside on a dyke night, complaining about the lack of dykes, as do all the other not-dykes there, and when I leave it is sunrise. The summer doesn't pass any differently when Jackson returns to Australia, after his last morning when we get matching tattoos that say, *NO BAD,* with a smiley face in the *O,* which Jackson pokes into my arm in the hurried moments before the airport.

People sometimes think there's sadness to my romances because I prioritize long-distance relationships and relationships with people who are already in love with someone else. As Jackson not only lives in Australia but also has there an Australian girlfriend, he's really ideal for me, both open to the love I offered to the many-handed hunger of transsexuality and also physically unavailable for at least eight months. Long-distance is maybe misleading because it's not distance (linear) so much as space (four-dimensional) that matters. When my ex-girlfriend or Simon or my ex-boyfriend played the game of exchanging visits with me, it was not as though there were a long line between, connecting us through distance, but rather we were the two endpoints of a hypotenuse and about us spun a sphere through which we could exalt and retreat. So I am certainly sad that Jackson left, and his return the next summer, after I have moved to Chicago and started teaching college, seems far away, but space isn't really a problem for me, just a comfort.

"Untitled" (Orpheus, Twice) is two mirrors, side by side. They are full-length, beginning at the floor and extending as tall as a tall person might stand, a slight space between them. You can position yourself to be reflected in one mirror, the other, or almost both,

your full body or a severed portion of it.
You can also turn away, unseen in either, but still there.

A certain type of full-length mirror is called a psyche.
These were old mirrors, adjustable by screws,
two pillars suspending glass that could be tilted to the flattering angle, a system of pulleys to change the height.
To paint a mirror, people often use silver.
This is because in life a mirror is silver, even when it reflects nothing but a strong crimson, or blue—
if you stand in a white room and face a mirror, you look back in silver.
Like how a smear of nickel has no facial features,
the word *psyche* has a sustained hiss to its meaning.
It is when life is blown into you and so you breathe,
but also it is all the things of imagination and materiality that make us, the seamless union of our consciousness and our unconscious, into an *I*.
It is the universe encountered through the personal, a word so sibilant you can forget you heard it.
Over time, people began to hang their mirrors on their cabinet doors, and no longer needed the cheval glass.

In the spare imaginary of Gonzalez-Torres, there are often pairs.
Nearly as often, he suggests that we think of these pairs as lovers.
They are "Perfect Lovers," "Alice B. Toklas and Gertrude Stein," "Lover Boys," or, "Orpheus, Twice."
Or two clocks side by side, two cords each ending in a light bulb, two chairs in front of a little television.
The twinned mirrors give us first this expectation, that we will see the lover twice,
and then the reality, an image of the self.

Two, to show us the point where the distinction between *lover* and *beloved* gives way to *me*.

In an art practice that returns to loss and joy, this coupling of Orpheus and Orpheus seems keenly both.

I practice at home, stand in front of a mirror, shifting my weight to become full, or half.

The gray luster feels mythological, beautifully so,

but the best-known moment in the life of Orpheus has nothing to do with his song.

It's just a man deciding he would rather see his beloved than any future the gods could promise.

I am looking at my face and seeing the specific shape of my cheeks when I smile.

I am turning to a mirror not for pain, obsessive plucking and pain, but to pat those cheeks.

I am trimming my bangs and humming, as the morning passes.

I feel warm, thinking of my old self, who was so pretty and at times so strong,

just as beautiful as I.

How sad, though, when beauty inspires the wrong want, when we respond to what extends beyond us with violence.

In the stories of antiquity, the goddess of love, Venus, grows one day intolerant of the woman Psyche, a human so beautiful that mortal language could not describe her.

Venus sends her son, Cupid, to curse Psyche, but as he turns invisible and gazes on her sleeping form, Psyche opens her eyes and gazes back, staring at the empty space where he is.

Cupid, shook, sticks his side with his arrow, falls immediately in love, and flees.

When Psyche cannot find a husband (too pretty, too cursed),

her father visits an oracle, who prophecies that she will marry
a horrible serpent that flies through the night.
On divine instruction, the family takes her to a cliff in a march
that is both funeral and wedding.
Swiftly, however, a wind lifts Psyche and brings her to a
beautiful palace.
There, shrouded in evening, Cupid's voice speaks, telling her
that this will be her new home, he her true love, yet ordering
that she must never see his face.
At night, he comes to her, this stranger, this captor, who believes
he is in love.
She lives like this for weeks, feasts appearing before her and
invisible choirs singing,
sometimes in despair, and sometimes in joy.
The voice of her husband declares that she is pregnant, and
that if she obeys him well, her child will be a god.
Endurance, however, can last only so long,
and when Psyche's sisters convince her that her husband is a
monstrous serpent,
she goes to Cupid in his sleep, ready to stab her way to freedom.
On seeing his form—
so gorgeous—
she pauses, lifts one of his arrows in contemplation, and, acci-
dentally stabbing herself with trembling hands, falls also in love.
Cupid wakes to see her there with a knife.
He flies away, and the castle disappears, and Psyche, now "in
love with Love," feels a profound loneliness land upon her.
A woman betrayed again, she throws herself first into a river,
and then, desperate, on the mercy of Venus.

I fell in love many times.
I used to be rapturous with it.

I felt it was an endless potential within me,
and that every time I fell in love with someone new, I would
be made new, too.
This is something like revenge, to fall again in love, after
someone has taken so much from me, touched painfully the
way I experience touch.
After the kind of violence that made me think, no, perhaps
love like that is not for me, that this is not a thing to which I
should be open—
to then fall in love, so happily.
Sometimes it feels like it just happens, a moment out of
nowhere.
Like I see a guy with his curly blond hair and that quick grin,
and I know that he will be someone to me, and then a moment
later he looks, and walks my way, and we go from there.
That feeling, that deep joy of possibility, it seems to come just
like that.
And what to do with that desire?
The best version of me isn't the person who falls in love, but
the person who takes love squarely for what it is,
as an occasion to know someone else, to learn about their
desires, to be each a better self together,
so long as that is what we both want.
To hell with all that hurt, whatever came before.
We can have a love where we are both happy, in which we see
ourselves for who we are—
standing there, where any story might begin.

So many cults of Venus, so many epithets, it is hard to say
which version of the goddess decided the fate of Psyche.
Venus sends her to fetch poisonous black water, the golden wool
of vicious sheep, a labor of penance.

Psyche goes to hell, even, in her attempt to please the goddess, to gain permission to love.

Psyche's quest ends when, at last, Cupid declares his devotion to her, and Jupiter grants the two permission to marry, so long as Cupid promises to fire his arrows at any disinterested women Jupiter desires.

At the celebration, Psyche drinks ambrosia and becomes a goddess in her own right.

She will live forever now, in love with a god who hurt her and who has promised to harm others in the name of love.

Like Orpheus, Psyche's life changes when she looks upon a face—Orpheus seeing his beloved for the final time, and Psyche seeing Cupid for the first.

What would they each have seen?

They would have seen a god and mortal, a man and woman, ravished by the failure of love, the violent misuse of desire.

Yet it is Psyche who resolves to walk through hell and who throws her body to the rage of a river when Cupid leaves.

Why should her story be failure or triumph, vengeance or sorrow?

She is a woman who refuses to relent, and she will come to name her child Pleasure.

"Once we believe that there is no God, that there is no afterlife, then life becomes a very positive statement.

It becomes a very political position because, then, we have no choice but to work harder to make this place the best place ever. There is only one chance, and this is it.

If you fuck it up this time, you've fucked up forever and ever," Gonzalez-Torres said.

When I first read the story of Orpheus and Eurydice, I remember responding with disbelief.

How could someone forget such a simple instruction, how could he glance?

But now that impulse seems the only possible one to me, to look over your shoulder to see if the one you love made it out of hell.

How could a person resist such a thing?

And when you have been in hell together, joined the person you love at the place of sorrow, the vomit and wind, where men's hands reach and grab,

I know this urge becomes stronger yet.

Some ancients, however, did not trust this story.

They wrote their narratives in judgment of Orpheus, a man who lived while his lover died.

They even question the moment itself, rewrite it so that Eurydice is no more than an apparition sent by the gods, mocking him and his beautiful voice as they ascend toward the earth, knowing he will turn.

There is a point, after all, between apparition and body, between first and last glance, somewhere on the horrible edge between death's finality and forever and ever.

There is a point where a mirror looks back.

So many stories, taking flight from crags and sinking into the floorboards, broken and held in the box of the language I've learned.

Yet standing in front of a mirror is such a regular thing.

It is a domestic moment, repeated several times throughout the day, a reminder that this is me, for better or worse.

I take pills to soften me, I paint myself with a bleached purple here and there, I inhale smoke into my hollows.

And it remains unpleasant, sometimes, to see this beautiful person, who knows so well more violence is coming,

that it's right out the door.

In a practice that suggests bodies spilled and gestured toward, *"Untitled" (Orpheus, Twice)* also seems to me one of the most embodied works.

Maybe that crude fact, that it is my own self filling that mirror, makes it so.

I want to state this again and again, to prove it to myself, the fact of being alone.

Even when penetrated by or entering another body, wound together like sheets, or torn,

glance into the past and future and the body is alone again.

What a relief that is, that any touch will end.

But a body absent a body is a body that cannot be set, cannot be anchored in place and subjected to the process by which we racialize, gender, assess through our senses.

It is the reason my friend Finn and I, driving a truck down Tennessee highways,

revel in remembering our first encounters with Gonzalez-Torres's work years past,

when they and I both understood a sense of a person that managed to unhinge itself from its frame.

The mirrors, then, are a rare instance where the body is mimetic, even in motion.

The only assessment, the only chance to make of it an object, comes from the viewer.

Despite all this, *"Untitled" (Orpheus, Twice)* still resists the larger mechanisms of control immanent in language and perception.

It still shows me myself, a person who might erupt in beauty, revealed to be alone, severed, formerly twice,

capable of desiring and making something of those desires.

Although it is not until much later that it dawns on me, that there would be a whole host of different stories,

were I to stand before the mirror with someone else by
my side.

In Virgil's take, Eurydice is bitten by a poisonous snake while
fleeing a shepherd who was trying to assault her.
Orpheus turns to his lyre, singing so beautifully of his sorrow
that the gods and the mortals, the living and the dead, all
open their hearts to him,
although they did not open their hearts to her.
Psyche, after she sees Cupid, likewise seeks pity and wanders
from the homes of her sisters to temples on hills, making pleas
to whatever gods might listen, although none does.
Both Orpheus and Psyche believe their wounds to be so deep that
they hope the forces shaping the universe will recognize their pain.
Empathy is a holy power.
To know another feels my pain, as even
"Cerberus held his three mouths gaping wide"
at the timbre of Orpheus's lament—
this allows a small part of me to abide in relief.
Empathy connects us beyond our physical form.
It feels like the unhinged body—
like a slight, warm sadness, at seeing two clocks set to the
same time,
and knowing they slowly tick apart.

In front of a silver mirror I want to dance.
I want to move my body back and forth, back and forth.
I want to split off the edges of it, squat and shuffle.
I press the mirror with my hands and I move my hips, and the
light is bright enough to show me my pores and the roundest
part of the nose when I pat powder to it.

I run a blade over my face, once, twice, and I bleed.
My whole body is silver, none of it is silver, the room is every
color that is in the room.
Staring is like the satiation of meaning, the repetition of
a word I didn't understand in the first place until it gives,
becoming pure sound.
Like this is my *lot, lot, lot,* and this is my *Sodom, Sodom, Sodom,*
this is what I *sought, sought, sought.*
My shoulders that sink in beneath their blades, I see,
and they are wide when I move them back and forth and do
not stay still.
This is my *lot, lot, lot.*
This is what I *sought, sought, sought.*
The words are caught in my throat and I am so beautiful,
so beautiful, and you can never have me.

When Gonzalez-Torres speaks of infecting power, he speaks of
power spreading.
An individual viewing his art can be transformed, having
been implicated and involved in it,
taking home a sheet of paper, tasting sugar, feeling.
A person in the world who has been affected by the pain of
another is an agent of change.
A person in the world who has been affected by the joy of
another is an agent of change.
A person in the world is an agent of change.
A person in the world, impossible as it may seem,
that's what I am, that's how I'll live.

Several stories address Orpheus after the second death of
Eurydice.

In some, he no longer sings to the gods of his youth but rather worships the sun, which glows so far away it can hold his affection.

In this story, the maenads take offense on behalf of the god he abandoned, Dionysus, and dismember Orpheus with their hands.

In other tellings, he can no longer bear the love of women and so turns instead to young boys, singing to them.

Scorned ladies then throw stones at the poet.

When his song is so beautiful that even the stones will not hit him, the women, in jealousy, wrench and rend his body with their hands, the scene orgiastic.

While Orpheus meets a base death, and Psyche rises to eternity, each believes the force of their love will serve as a sort of absolution.

Isn't that a wonderful dream?

That love can lead to mercy amid endless violence in the name of desire?

That someone else has felt my pain, and known my joy, and happily, still, looked back?

My friend Benjy made the gloaming, all-windows building that is on the cover of a book I wrote and that inspired the architecture of the shack I built and inhabited for a while in Tennessee. The cottage he built shines like someone is arriving in the moonlight, but the window framing on my shack is salvaged gray wood, spongy soft and without a good gleam. Before I move to Chicago I take a bus down to Tennessee to visit him. His house is similar, cedar slats and old barn windows for a greenhouse, row after row of flowers I can't identify, steps up the hillside so the top opens to a garden like the bottom does. Benjy moved here about a decade ago, after growing up in Oklahoma. When

I climb the stairs he's shirtless like he always is, a big beard and a hairy wide chest, and he has a genuine smile that doesn't seem to go away. "Sterling's flowers are doing amazing," I say. It is the part of summer that dips into fall and he shows me one flower, an iris that blooms yellow. It is still hot enough that every step is a bending of grass, white motes of gnats rising. The crawling flower came from Scotland, where Sterling spent the early nineties in an abbey on an island. Our friend Mathilduh visited the abbey after Sterling died, dug up some of the plant, and secreted it back across the ocean. Now it's in an elevated flowerbed with a bunch of perennials Sterling planted. Near it, off the porch, is an old air-conditioner top he flipped upside down and made into a hanging planter for some aloe plants. They propagate a bounty of baby aloes all summer long, popping out clones asexually. There are more aloe babies than a person would use so some of them end up unplanted, clumps of green spiky leaves with roots dangling out the bottom, on the sills of the screen windows.

Benjy and I have placed a mirror as wide and tall as my arm span on a card table in the flat bit of his front yard. The mirror shows sky, and beside it we set a ladder and his photography equipment. We dump all our prescription drugs onto the reflective surface, bottle after bottle. The pills are tan, light yellow, two shades of blue, one of red, a pale pink, and a paler pink with a purple hue. When they are all mixed together they look like pills, generically, unlike when they are in the bottles and seem direct references to our survival. The mirror's reflection of sky is both stark and creamy. If I place my hand upon this sky it does not ripple, but there is a fingerprint.

We are here to shape the pills into letters, which takes time, and so we chat all morning about them. Thousands and thousands of

dollars worth of medication, they are the most expensive material we have used to make an image. Another in a long series of changes to Benjy's HIV treatment plan and insurance access in the deeply conservative state means that most of these are not pills he is taking but rather pills he has taken. They are pills that worked, pills he can't access anymore, cocktails of pills that might or might not act on the body with greater efficacy to suppress his viral load than the cocktail of pills he took this morning. I contribute only three varieties to the mirror, synthetic estrogen and two kinds of testosterone blockers. These pills, too, have been rendered different with the sudden announcement that there's a shortage of injectable estrogen in the United States, a combination of FDA policies and disinterested manufacturers conspiring to end the production of the oil. I've never gone for a shot, and sometimes I mail people pills, just as sometimes friends sent pills to me when I ran out. On the mirror, smooth like the oil is slick, the pills roll with the slightest wind, or when my hip grazes the table edge. My feet, too hard on the ground, make all the blue and white and yellow and tan quake at once. It is 2015, the beginning of the estrogen shortage, Benjy and I joke.

Benjy and I make pictures because it's fun and we want to, so we work at a very slow pace, punctuated by beer and cigarettes. These digressions, we decide early on, are the most important part of our process. Today, we read from our list of phrases, academic and technical terms we plan to misuse, ideas like "object orientation" that we will interpret for our personal meanings rather than the meanings everyone else finds in them. I have no skills when it comes to making art, no training and no eye. This is one of my favorite parts of our collaboration, the idea that someone can just make something anyway, away from institutions.

We're investigating the language of the present from the perspective of the utopic, which is an exploration of difference, and the only way we can find to this language takes us through each other. If the utopic is a post-queer moment, I think that the friendship I share with Benjy can be a part of that. If we have a shared identity it is that we identify with how lovely it is this morning, and the way we talk about our politics is by trying to make something for our friends to enjoy.

I count backward to figure out when I started taking hormones— Seattle, Brooklyn, moving away from the South, Berlin with Simon, falling in love with Otelia . . . I land in some summer, I don't know when. I distrust linearity, but bodies can seem like one of the only linear things—age, getting bigger and then smaller, death. Another reason to appreciate the transitioning body, which ages backward, every person seeming to become younger, with or without taking hormones. It's a good reminder that the body was never linear in the first place. And anyway, when wasn't my desire pubescent? I didn't know what I wanted until I had it, which was just to feel different. And when I swung a hammer, my inner forearm landing against a new, warm shape, I tired more quickly, and was happier for it.

Benjy and I use maybe one hundred pills. *Post-Scarcity,* they spell out. The word is multihued and large. I hold the ladder while Benjy positions the camera above, and as the clouds pass in their own game of arrangement, he snaps a picture, waits, snaps a picture. The images show only pills and sky, and it appears as though the word is floating above us. *Post-Scarcity,* it says, composed of more than one body like all bodies are. I use the crook of my elbow to sweep the pills into a bag and we return to the house, sorting them from one another again, putting them back

into bottles. Categorization isn't how we acknowledge difference, but rather its enforcement, difference leveraged to keep things apart that could well be together.

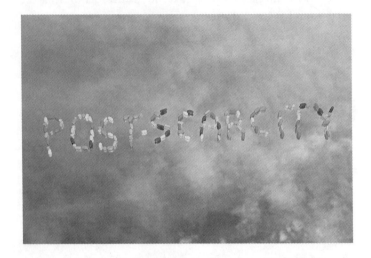

After we snap the last photos, I throw my stuff in the back of a truck and catch a ride from Tennessee to Chicago. I lived in Chicago for a summer when I was twenty, and when Simon and I met we realized we had lived a block apart from each other, as he scraped by in art school and I rollerbladed to my internship every morning. Maybe I lean on coincidence a little too hard, sometimes, when I'm trying to decide what matters, but I was pretty delighted when I figured that out. Anyway, Chicago today has as much to do with Chicago then as I have to do with that wide-eyed twink on rollerblades, too embarrassed to ask anyone how the buses worked.

To make a bedroom, I hang a curtain across a large room on the second floor of a house, where the windows overlook a quiet street

and where my new friend Stevie makes occultist artwork, such as a claw machine, built like the game at a bowling alley, stocked with neon yellow earplugs and in which a living tarantula sometimes crawls, its furry little legs on the compressed foam. Years ago, when they were coming up, Stevie lived in a punk house with one of my best friends, which is how we came to meet each other. I work on transplanting my routine to this new life where I know almost no one and where I spend the days in meetings or teaching, smoking weed out of a carved-out potato in the evening and then going for long walks. I bring some things from my old life with me, heavy boxes of books and a writing routine, and leave other things behind, replacing my tattered T-shirts one at a time with pencil skirts and jumpsuits slightly more appropriate to the classroom. Stevie introduces me to art people and we talk about the possibility that the ice machine at the bar where they work is possessed, which I decide is probably true. "That sounds like something people I know would say," I say when they first tell me of the possession. I begin to make friends slowly, but, unfamiliar to myself in this context, I feel as though a claw is going to grab my head anytime I leave the house.

Some old friends come to visit, to alleviate my move somewhere I have no old friends, and so we go to the gay beach. Among them is my ex, Otelia, a beautiful alien who came down from the stars to gift us all with light and joy, and who is the love of my life, and who has my favorite dog in the entire world, too, a little chubby orange thing named Georgia, who bites people, but usually people I don't like. When we all get to the beach, the Chicago-area people of the Michigan Womyn's Music Festival are having a reunion lunch, and many dykes are gathered. Otelia and I take pictures in front of the welcome sign, Georgia like

a baby in my arms, and then try to get the women to give us some of the hot dogs they are roasting. The first people we talk to as we wander closer have warm smiles and remind me of the dykes I love who went to the festival; of the fact of their going, I refuse to have any feelings. Only a few weeks ago MichFest announced that the latest festival would be their last, the tradition closing after thirty-nine years. The organizers refused to officially welcome trans women despite decades of protest for inclusion, and the debate reached such a pressure that the festival collapsed, its ten thousand people ungathered by their refusal of other women's bodies. Especially absurd, as trans women were already attending the festival, already part of those communities. The dykes on the beach, they sit with their feet in the water, with smiles they have been practicing for fifty or sixty years, smiles from before the first gathering of womyn. One wears a t-shirt with the sleeves cut off, like Otelia does. It is always so clear when dykes love each other. They say they see us and they welcome us, and we chat for a bit—what a lovely lake this is, I've always loved the Great Lakes, we all appreciate this place where we are. There is not much to say, but we say a few things anyway, and we laugh together, and I don't ask them for any of their hot dogs after all.

Tired from the sun, I bring Otelia to the modern wing of the Art Institute of Chicago, which has *"Untitled" (Portrait of Ross in L.A.)* on display. I try to see the things I'm writing about when I can and this piece is shown pretty regularly. It's in a corner of a room up some stairs, like it usually is (maybe not always the stairs though). I don't like this route of approaching, with a twenty-five-dollar general admission, but I pay it to get the experience of approaching and then touching, in that order, and then taste. I think about the people I know who have died when

I do this, but I try mostly to fill my mind with Felix Gonzalez-Torres and Ross, and to accept the portrait that is given to me.

In a 1992 letter to his gallerist, Gonzalez-Torres reflected on another one of his takeaway pieces, a stack from which you can take an "uninscribed piece of paper," which he called *"Untitled" (Passport).* In the letter, he considers the blank paper a source of beautiful possibility, "an untouched feeling." In the same breath of thought, he offers that this paper, once it is taken from the stack, should be inscribed with "the most painful, the most banal" as well as "the most sublime." It's a dream where anyone can just walk up and take a passport, which is, yes, sublime, like love—and then we take that paper back out into the world, where passports are denied and seized, love severed in the process. As in an interview with Tim Rollins:

> FGT: There is also, of course, Yvonne Rainer's *Journeys from Berlin* and a movie by Sara Gómez called *One Way or Another,* which is a feminist view of the Cuban revolution, Santeria, and other issues. This movie is very interesting because it's also about the meaning of love during a particular historical period. I saw that movie the same week that I saw *Hiroshima Mon Amour.*
>
> TR: That's a great movie about love.
>
> FGT: No, it's about meaning and how meaning is dependent on the context.

An annoying thing about gender is that it always gets in the way of people understanding context. Gender confuses people. They are being transformed by it and they don't pay it attention.

They focus on the language too much and forget to get every-one housing and health care, for example, and they argue for the inclusion of trans people in the military as though the military isn't perpetrating mass violence and unprecedented environmental destruction. This is another reason I would like to be uninscribed by language, like an uninscribed piece of paper. Of course, this is not literally true: I've written all over myself. There is the *NO BAD* on my arm, some in-joke acronyms in blown-out ink on each hip, the word *shed* on my ankle, and the phrase *love me, go away* on a leg. At first it was simply *love me,* and my mother used to say it made her sad whenever she saw it, and then I added *go away,* and she said, "Now that makes me even sadder," and never brought it up again.

It's taken a lot of resistance, that I want to leave my gender and my sex life uninscribed—that it took me years to consider the fact that I did not have to name my gender or sexuality at all, so that now I must always tell people that I am not something. I insist on this absence more, even, than I used to insist on my identities, that I was a bisexual boy, or genderqueer, or a queer, which was actually just unpleasant for me in lots of ways, come to realize. I stand by only a quarter of what I said when I was queer. Queerness, when I first encountered the idea, aspired to a life away from identity categories, eroticizing what lies outside them, but today it seems the word often points to a reification of identity, to new rules. The uninscribed, like Gonzalez-Torres says, is a site of change, where I might understand my actual context and do something about it, rather than getting tangled up in a game of words, and so that is where I would like to focus. I am of course still written into this whole structure, I can't escape the language, but that won't stop me from refusing

it anyway, and believing that a blank paper might transport me somewhere else.

That I'm never really in a relationship in a recognizable way puts me at odds with identity also—single and coupled, available and attached, free of the expectations held by boyfriends and girlfriends. Jackson and I settle into a rhythm of first texting all the time and then Skyping. He's a guy I Skype a lot, is what he is. Sometimes at the end of the conversation he shows me his butt, and I make him a little video where I dance around and jerk off in a pair of heels with Bongwater's "The Power of Pussy" playing too loud, blaring. To keep us focused, we begin a plan to sneak-install sexual sculptures at the historical sites of gay cruising in Chicago, sites that are new to me and in a city he has never seen. We talk about simple, lightweight constructions with a minimalist design intended to enhance and (very subtly) encourage pleasure-seeking—at a long bit of high plants at the side of Lake Michigan, for instance, he suggests a very short wall, placed just so to offer total privacy to a couple horizontal people.

I would take a legal risk, even if only minor, to honor faggots, because I sometimes feel I have been denied friendship with them. I was surprised how I ended up spending less time with gay men when I stopped claiming that identity—although of course it would be that way, I realized later. Being a faggot sometimes felt like installing the sculptures would feel, like a fear of someone catching you doing something, and in a place you weren't supposed to do it, which is very different than the feeling I often have now, which is as though everyone is looking at me and what are they going to do about it. So many different

ways to be illegal, these constantly overlapping conscriptions to our behaviors by the state, and the countless ways they enact themselves onto us or through us. I dream the sculpture's wooden weight would somehow be a blockage in that system—clunk, clunk, every time someone is happy because of it.

As fall begins to exert its emptying onto Chicago, I become aware both that the cold is near and that I've barely had sex since moving to the city. These are linked because if I do not figure out how to have sex in this new city soon I will sleep alone all winter, everyone hiding inside and covered in blankets and sweaters. I find sex differently, depending on where I am. In Seattle, the best way to find someone to have sex with was to go to a basement where maybe a band had been playing or to this one punk bar with dicks on the walls. In New York, walking on the street between any two places seemed to work well, while in Berlin I just kept taking drugs when they were offered to me and then when someone suggested a different party, I went to that new party, and I had sex there. Chicago is different, though. I even have to actually quit smoking here, where my Virginia Slim Menthol 100s are fourteen dollars a pack, which is the same as in New York but also, actually, too much. No one here knows I used to wear different eye shadow, here where some people call me "T" instead of "Clutch," an old name back again. Soon I'll put on a long puffy coat and then even the people who recognize me won't recognize me when I'm walking toward them.

The lingering warmth of fall means I'm more often in a light jacket over a dress or a button-down collar and skirt, my shape still available. I never really write poems but in Chicago sometimes I write a poem, I think because of all the transit. Being

vulnerable to other people's hands and voices twice a day makes
me want to think about what is inside a moment, which poems
are good at doing.

Less Again

I am walking to the L to go
downtown to the Loop and
on seeing me some of the men
passing on Devon Street
become taken by the thought of
or maybe an image of penis
which they hadn't been
thinking about before
(this happens also on the train
and then the walk from the train
although different men)
and perhaps it is their penis
and perhaps it is my penis
they really can't distinguish
some of them can't and just
as the owner of the penis is
mutable so too the turgidity
how or if the thought is sexy but
I don't notice these men
I hadn't thought of them
until right now as I am sitting
in my office and even if I try
I can't recall how they look
their hands that were probably
near their knees or hips
or the cuts of their hair

more blood in their cheeks
and then later less blood again

I write poems in my office and I feel a lightness because I like my poems to be small moments to consider a thing and to have thought through it to let it go. You can claim your power, in a small moment like that, with a poem.

I have to make my own way, putting things aside and going ahead, picking other things back up. With winter fast approaching I open an OKCupid account and say that I will do the "36 Questions That Lead to Love" with any trans person who is interested, dinner on me. The thirty-six love questions became popular when the *New York Times* wrote about how asking and answering those questions could make strangers fall in love. You sit across from someone you don't know, taking turns back and forth asking these increasingly vulnerable- and personal-seeming questions, and when you've asked all of them you stare into each other's eyes for three minutes without saying anything, and then, poof, you're in love, motherfucker. The instructions don't say how to make this work for anyone who isn't sighted, so I'm not sure how much the staring is part of the connection or if it's more something snazzy for show at the end. Lots of people actually do have healthy and long-lasting and joyful relationships after doing these thirty-six love questions, which makes it seem like we're all boring, horrible creatures who would get along fine if we just shared some information about our lives with one another, but who refuse to. If it works, though, it seems like a brilliant trick, like I will pull a cord and love will fall down onto me endlessly. I put up my profile and set a goal, that I will do this thirty times, and when I am in love with thirty people, I will have a horrible and wonderful party where I introduce all thirty to one

another, and they will have nothing in common but their love for me. We will all then have gone through something we feel weird about and that we don't totally understand—an experience only we will ever understand, deepening our love.

Weeks pass (I read Etel Adnan's two-volume selected works, *To Look at the Sea Is to Become What One Is,* and, voraciously, a stack of comics) and then finally one person takes me up on the offer. Their name is Ryan and they are very beautiful and I talk to Jackson about how gorgeous their smile is in their profile picture. When our date comes I wear an olive-green fall jacket over a mustardy green romper. We sit down and we say the questions to each other. We say, "Do you have a secret hunch about how you will die?" and "What do you value most in friendship?" and "If you were to die this evening with no opportunity to communicate with anyone, what would you most regret not having told someone? Why haven't you told them yet?" We sit on the outside patio of a cute little restaurant, and they are quite beautiful, and as it turns out we are of the same loosely accumulated trans social fabric of activists and artists. I put my blazer back on and we go to the park where we stare into each other's eyes (their eyes are beautiful) and then decide we are not in love. A week later we have sex, and a couple of weeks after that I see them at an art gallery, but we can't really talk because they have injured their tongue giving head the night before.

I do manage to scrape together some sex on Scruff, although I'm interested only in people with complicated genders, and everyone is so young. I prefer dates who are at least thirty years old, who are good conversationalists, and who are too busy to really hang out. I mainly, however, wonder at this new problem, where an active and healthy sex life disappears and I am in love with

someone on the other side of the world. These are related only because they are happening at the same time, but happening at the same time is a relation anyway. It makes it feel as though my desire has been drawn away a bit. It also does not help that my few attempts at finding a date nondigitally fall flat. "Want to have a date sometime?" I say to several people, and none takes me up on the offer. The critic who did not go on a second date with me even passes through the city to give a talk and does not go on a second date with me again; he invites me to meet up and then I go home and he goes somewhere else. I have occasional exceptions, falling into group sex with a bunch of rowdy, drunk trans girls, but mainly I find that sex is now elusive, in the past, and that while my body is no less mine than it has ever been, the conversation in which it is made explicit quiets to a monologue.

At the same time, my days become increasingly filled with professional activities: presenting ideas to a committee of strangers, attending a meeting followed by another meeting, giving a lecture. Each of these are instances in which I have to talk, and in which everyone else listens to me and looks at me. The way people react, I know that they are thinking about what they would call my gender and, in the way most people find gender and bodies to be irreducibly the same, that they are thinking also of my body, the small weight of my breasts maybe visible in a sweater. I know that when I am talking to a large group of people, in their heads are odd confusions about me, and that when I am talking one-on-one, a slight nervousness sometimes—the fear that they will say the wrong thing, and their language will reveal how they see me.

I am expected to come and to talk, to be inside of an institution, to hurry to the basement of a different building where I can find a bathroom, and then to walk into a room with cloth hanging on

my shoulders, and with my powdered face with hair in it. It is as though the institutional architectures of buildings and policies are forcing me to talk about language, about pronouns and bathroom signs, which are not things that I care to talk about. And when I am made to talk about those things anyway, the ache of my bladder and the student harassed by faculty, that is when people turn away from me. No one tells me, we just all know, that my job is to say something that will bring us elsewhere, to a place everyone can be comfortable. No one tells me this but I can see their faces. I can see we are all scared by what we aren't saying.

Next morning, two friends, who had been at one of their meetings, gave forth a report of the awfulness of the solemnity with the innocent yet majestic appearance of the woman preacher, that they were struck with wonder and amazement by her preaching and praying, which were wholly in the method of friends or quakers. Thus her behaviour, conduct, and appearance soon sounded abroad; and on the succeeding evening an unruly company assembling, it was thought prudent to keep the doors and windows shut, there being apprehension of personal insults from the liberties taken by boys, &c. A dreadful scene of outrage ensued; stones, brick-bats, &c. were thrown against the house; which was contrary to the laws of hospitality.

—*The American Museum,* February 23, 1787

Begin with the Death Book of the Society of Universal Friends, a bound record of the deaths of the members of the religious sect founded by the Publick Universal Friend, called the Friend, the Comforter, the All-Friend, and so forth. "By living witnesses of the deceased, I have the following history," the faithful Ruth Prichard records at the start of the book. Scripted behind the front cover years later, "25 minutes past 2 on the Clock,

The Friend went from here" marks the death of the Publick Universal Friend on July 1, 1819. The deaths of other friends and followers continue, written in varied hands, until 1830.

As this strange group writes it in their Death Book, to be "yet in time" meant that one was living, while those who "left time" were dead. "Huldah Botsford left time," and "The Aged Freelove Hathaway left Time," and "Jacob Weaver, an Ethiopian, left time." Other followers received more ink than these brief notes. The book's entry on Mehitabil Smith, for instance, shows the Friend graveside, quoting Ecclesiastes 7:2, that "this is the end of all men; and the living will lay it to heart."

Long before "25 minutes past 2 on the Clock," before founding and leading this group and keeping the tally of their deaths, the Friend lived a quiet life near the ocean. They were born in what they then called the Colony of Rhode Island and Providence Plantations, of the Kingdom of Great Britain, and named Jemima Wilkinson, the eighth child of a man who grew cherry trees in his orchards. Lawrence Wilkinson, the Friend's great-grandfather, was the first Wilkinson to arrive on the continent. He had served as a solider in England, defending King Charles I from Cromwell, until his estate was seized by Parliament, causing him to flee to Providence. There he received twenty-five acres, selected from a large parcel of land granted to the English by the Narragansett people, who had lived there for thousands of years. Over several decades, Lawrence expanded his holdings to around one thousand acres. John Wilkinson, his son and the Friend's grandfather, acquired more acreage from the Rehoboth North Purchase, a sale of land arranged with the Pauquunaukit leader Wamsutta. When the governor of Plymouth Colony decided he did not favor the sale with Wamsutta, however, he

had him arrested, leading first to the sachem's death and then, in 1675, to the bloody King Philip's War, which drove many indigenous people out of the region and into other tribes. It was said of John in that war that "he feared nothing in human form, and his rashness was sometimes checked by severe casualties." Living a much quieter life, the Friend's father, Jeremiah, held only a small parcel of orchards, which he inherited from that Rehoboth North Purchase, and which provided for his family. It is on these acres in Cumberland that young Jemima Wilkinson played, climbing the rock ledges and roaming a nearby swamp, until, at age thirteen, their mother died, and they became an adult.

One day—the year, as it were, in which a new nation was declared around them—a disease spread through this Rhode Island town. Perhaps it was typhoid, or perhaps what people of the time called "Columbus Fever," named after a military ship that held British prisoners of war, docked nearby. Regardless, the fever caught Jemima Wilkinson and, slipping out of the conscious world, the twenty-four-year-old also expected to leave time. Instead, however, they soon shot awake. They then spoke, declaring that Jemima Wilkinson had gone to heaven, and that a spirit of the Lord had removed the fever. A genderless holy entity now inhabited this body—the Publick Universal Friend, they declared their new name. As the Universal Friend of Friends describes it, the archangels

> *putting their trumpets to their mouth, proclaimed saying, Room, Room, Room, in the many Mansions of eternal glory for Thee and for everyone, that there is one more call for, that the eleventh hour is not yet past with them, and the day of grace is not yet over with them.*

Later, the All-Friend's brother told them that, in the fever, they had declared simply, "There is Room Enough."

The Friend quickly took to sermonizing, spreading the word divinely given to them, announcing their miraculous rebirth and extolling the virtues of celibacy, restraint, and humility. They started to wear masculine clothing and a hat made out of beaver pelt, which they would remove when indoors, and they cautioned, sternly, against pleasure. Regularly, traitors of the American Revolution were executed in town squares near Cumberland, providing the Friend with easy audiences, and occasionally with converts, true believers who would invite the All-Friend to come speak in their homes, or a nearby public meeting house. Some evenings, the Friend received divine messages in their dreams, which they would share in the next day's preaching. Some of these prophecies were very specific, and the Friend was confident enough to predict the exact day of the apocalypse, which would arrive on April 1, 1780.

Before the apocalypse could come, however, and after two years of preaching in the smaller towns of Rhode Island, another divine message told the Friend that they must go to England, back to the country their great-grandfather had left, to spread their word. While they received permission to make the trip from the commander of the Revolutionary forces in Rhode Island, General John Sullivan, after traveling to Newport and preaching there, the plan fell apart, and the Friend instead relocated to a new follower's farm near the village of Little Rest. The apocalypse of April 1 likewise failed to arrive, but just a short while later, on New England's Dark Day of May 19, smoke from the nearby burning of forests

rose and blew until it met uncommon cloud formations and, together as one smoke-billow, blocked completely what had been for days an unusually red sun. No one of the time knew the source of this darkness—a solar eclipse? a volcanic eruption? It would be many years before the truth was known, that fires had consumed forests hundreds of miles inland, north of the vast lakes, and that it was this smoke, its great plumes, that turned the day to night. Fearful of the darkness, people lit candles at noon, and many prayed. The Friend, however, saw this dark sky and recognized it as exactly what they had predicted, as an apocalypse coming, albeit six weeks late.

The same day the sky turned dark, the Friend's devoted follower Susannah Porter perished. Susannah had been one of the Friend's favorites, but when they tried to resurrect her, Susannah's faith proved too little. "She died in the Arms of the Friend," the Death Book states, one of its earliest records. After Susannah's death, it seems the Friend found little need to stay put. They soon left Little Rest and the towns they knew, striking out for bigger cities, larger crowds, and more followers.

Although, as in the smaller towns, the people of the urban hubs were more often hostile than friendly, more gawking than welcoming. The All-Friend, for instance, visited Philadelphia with six companions for the first time shortly after the end of the Revolutionary War, where they struggled to find lodging, turned away because of their strangely gendered attire. When at last a widow agreed to put them up for the evening, the people of the city battered her home with bricks. Over the following days, the Friend converted one person to their

teachings, and met a man, a widower, who would become a lifelong friend and correspondent—few converts for a long trip, although curiosity about their strange preaching style and clothing, as well as the Friend's striking beauty, meant that hundreds of people filled the halls of their sermons. They "appeared beautifully erect," one man noted, while the Marquis de Chastellux, coming across some of the Friend's followers in Philadelphia, was struck by the "young men . . . with large round flapped hats, and long flowing strait locks, with a sort of melancholy wildness in their countenances, and an effeminate, dejected air." Who were these strange people, who call their leader "he"? And who was this preacher, so strikingly beautiful, and with a voice that sounded like a "croak"?

Then as always, the words of the Comforter's sermons were not unique, but largely stolen and repurposed from the Quakers who had raised and then disowned them. When they were caught plagiarizing the texts of Isaac Pennington and William Sewel and publishing those exact words as their own, as *Some Considerations, Propounded to the Several Sorts and Sects of Professors of This Age,* their followers simply explained that the holy spirit had spoken the same language to all the faithful. Why should the truth be different? they asked, with their leader who was different.

Yet the Friend of Friends kept traveling, city to town and then back again, a dozen or so followers alongside, officially founding the Society of Universal Friends in 1783 and earning the notice of other religious leaders. "Saw Jemimy Wilkerson the Imposter with the number of Deluded Creatures that go about with her standing &c in the road," the Baptist minister

John Pitman wrote in his journal. A master equestrian, the Best Friend moved quickly, attracting bigger and bigger crowds with their companions in robes that obscured their shapes, side-saddle on their rides. But word preceded them most anywhere, critics with anonymous names like "vox populi" and "z" writing to local newspapers to decry the sinful preacher. These letters warned and damned and disparaged and despaired. These letters made demons out of the Friends, who were blasphemers, thieves, perverts, undermining the bedrocks of Christian society. Once the Comforter's numbers had grown, the faithful in the hundreds, word spread of a near murder, the women of the sect attempting to strangle in her sleep a new member who had questioned the Friend's mystical powers, although what those powers were, that remained unclear. Despite the controversies, however, followers kept joining. Some heard the plagiarized sermons and left their families behind, abandoning wives and husbands and children and aged parents, while others offered their families, homes, and fortunes to this strangely dressed prophet, all that they owned subsumed into the promise of the Friend.

And so the followers came as full families, as widows and widowers, a few formerly enslaved people, a few unmarried adults. Some of the mothers adopted the Friend to all Mankind's manner of dress (hair down like a man, unadorned and flowing robes), obeying the demands of plain speech, and likewise devoting themselves to celibacy. Use *thee* and *thou,* the Friend said, and punished those who didn't, ordering one man to wear a small bell for several weeks after he talked informally. One follower in particular, who would come to live with the Friend and even hold their properties in her name, was the best at following these rules; she called herself Sarah Friend,

and became as close to a second as there was in the society for years. She dined with the Friend, and she sometimes wore sackcloth, styled after the two witnesses to the apocalypse in the book of Revelation, who had the power to bring drought, plague, and famine to the earth. She even provided the Friend with more dreams than the other faithful would, taking seriously their belief that all dreams could be prophetic, and sharing visions of twin moons, and of deathly grooms in ash-colored clothing. Other followers listened to the Friend, but never quite as closely as Sarah did. Those women were granted permissions to marry and to bring babies into the world, set toward apocalypse though they may be. They wore their hair up.

Can "yet in time" be removed from the world? The world was, at best, a distraction, all gossip and sex and other such unacceptable behaviors, at least so far as the Friend could make sense of it. This world would not do, and so the Friend sent a party of followers west, to what they would have called the frontier in New York, to found a settlement. They imagined it would be a land apart, where they could live according to the plain rules they preached, and wait out the clock of death. The Best Friend sent the strongest of the sect to settle this land, the repeated trips beginning in 1785 with a journey Ruth Prichard describes as "snow this day under the load of snow," and the final spot chosen in 1787, when the sound of a waterfall drew followers to the shores of Seneca Lake.

This land the Friend hoped to make apart from the world, yet still in time, was home to the Seneca people, who had joined the powerful Haudenosaunee Confederacy half a millennium before, brought together by the Peacemaker under a

solar eclipse. For centuries the Seneca thrived, planning from their villages of longhouses commerce that stretched hundreds of miles, joining the fur trade, and conducting war and complex diplomacy with colonizing forces and other indigenous peoples, all from their strong position within a confederacy whose political structure the colonizers would, in part, appropriate for their own government. The confederacy had signed between fifty and sixty treaties with the British, French, and Dutch, beginning in 1613, each of which the Europeans violated. In 1775, they signed another treaty, promising to the Americans that the confederacy itself would remain neutral during the Revolutionary War. As the Americans pushed farther into Haudenosaunee territory, and as their rhetoric became increasingly hateful in speaking of the Haudenosaunee, some individuals of the confederacy joined forces with the British, just as some also joined with the Americans, but the confederacy on the whole kept its word. After the war, vengeful of what he saw as a betrayal and seeking land, George Washington sent Major General John Sullivan (that former commander from Rhode Island) with roughly one quarter of the Continental Army to wreak devastation on the Haudenosaunee. Begun in 1779 and finished in 1780, the Sullivan Expedition was one of many horrors, the burning of homes and crops and the destruction of any locatable resources, up the Susquehanna River to the Great Lakes, with the majority of the indigenous people driven north and west as refugees. For the most part, word of the march traveled ahead of Sullivan's six-mile-long army, and the Seneca abandoned villages like those a few miles north of the eventual site of the Friend's settlement by the time of the Continental Army's catastrophic arrival. Still, were the Haudenosaunee to offer peace, Washington instructed, they should receive only "terror," and

Sullivan's men continued on, writing in their journals of the beauty of the homes and orchards they destroyed.

After Sullivan's march, the Americans and the Haudenosaunee signed another treaty at Fort Stanwix, which marked a large circle of land, from Lake Ontario down along the Ohio and Susquehanna Rivers, as belonging to the Confederacy, and promising that no settlers would come there. It is to that land that the followers of the Friend went, among the very first settlers to violate that boundary after the march of destruction—the Friend to All Mankind, as they called themself, the Best Friend. They went to await the apocalypse, prophesied to them with fire and darkness, those very things that had preceded them, and on which they built their dream, what they had always imagined to be right. The followers went a few years after the treaty at Fort Stanwix, girdling trees while the Americans kept promising, with new treaties and more laws, that settlers would not come to this place.

The specific land the Friend and their followers bought was a part of the Oliver Phelps and Nathaniel Gorham Purchase, these two men having acquired millions of acres of Haudenosaunee land through complicated deceit. Colonel John Livingston also claimed much of the same land, which he had also acquired duplicitously. The parcel the Comforter purchased from these acres happened to lie on the Preemption Line, which was drawn by the governors of New York and Massachusetts when they divided the land between their new states. As no state or person in the new government could agree on who owned these lands, then, the Friend found their property in flux, shrinking from fourteen thousand promised acres to a slim tract, eleven hundred acres large, called "the Garter."

Eventually, their followers were able to raise enough funds to acquire roughly ten thousand more acres, for which they had to pay twice, after Massachusetts and New York decided to again move the Preemption Line, resetting the boundaries once more.

By 1790, the Friend ceased their constant travels and relocated to the settlement, spending their first few years on the western edge of Seneca Lake. Their followers built the first grist mill in the region, and went from surviving on boiled nettles to sharing full and hearty meals, as their numbers grew first to one hundred, then two. Over time, living in this growing hub became less appealing, and the Friend planned another move just a dozen miles westward, to a place they would call Jerusalem. Sarah Friend went with them to select a spot on which to build their new home, which, like much of the land, Sarah kept in her name (legal papers being too earthly for the Friend), although the two could not agree on a location, with the All-Friend deciding on a hill farther north than the spot Sarah preferred. As followers began clearing the trees for them, however, Sarah fell ill, and after seventeen weeks of illness with the Friend as her nurse, she succumbed to her sickness and died. The Death Book tells us that the Friend preached for a long time at Sarah Friend's funeral, when she "left Her weeping friends to mourn." The "righteous is taken away from the evil to come; they shall enter into peace; they shall rest in their beds," the Friend declared. Less than three months later, they left the settlement, and relocated permanently to Jerusalem.

The home in Jerusalem was at first quite secluded, down a thing that was barely a road, with only a small number of settlers and of returned Seneca people for neighbors, but

the Friend welcomed many of the celibate women and more impoverished members of their sect to join them and make a life on that hill, and the population soon grew. The followers built additions onto the Friend's log cabin, then more, covering it later with clapboard. It was a strikingly large and handsome dwelling, and the Friend joined in sawing wood and hoeing the garden beside it. All the while the United States of America, now articulated as such, continued to grow around them—with its walls, and its slavery, and the disagreements it has with itself, and its ceaseless wars. The Friend, though they pretended to be hidden away, still took part in the building of the nation—with each house they built, each friend they brought west, each garden they hoed.

Around the sect, too, the Haudenosaunee nations continued, consolidating near Niagara Falls. By 1794, when Colonel Timothy Pickering went to establish yet another treaty with the Haudenosaunee on behalf of the United States, the Friend was in prominent enough standing that Pickering invited them to visit the council. While some Seneca warriors had argued for war to defend their land, the Seneca women had vetoed that plan, as was their right, tradition ensuring their voices had a place in decision making. The Haudenosaunee then met with the representatives of the United States in Canandaigua, a town of settlers about fifteen miles from the Friend, built near the site of the Seneca town of Ganondagan, "the Chosen Spot," which had been destroyed by both New France and Sullivan's raid. The council began in Seneca tradition, honoring those who had died since the last meeting, and presenting the Americans with another promise to keep friendship. Over a thousand Haudenosaunee were present, and the council lasted for six months before the Six Nations reached a consensus, at

which point the United States agreed to recognize the confederacy as a sovereign nation. A six-foot wampum belt records this truth, and is held by the Onondaga Nation. The boundaries established by the treaty endured, despite regular attempts by the United States to violate them, and just as the Seneca Nation will surely endure long after the United States has fallen and its borders have crumbled.

The Friend even spoke at the council meeting they attended— unusual, at the meetings of the Americans, for someone who was not a man—falling into loud prayer, then spreading their same old message of apocalypse and redemption, ranting on until it was dark, past when their audience cared to listen. The following day, some Seneca women in attendance used the Comforter's impromptu sermon as an opening to address Colonel Pickering's council themselves. Describing this part of the negotiation, the Quaker preacher William Savery wrote in his journal "that one of the white women had yesterday told the Indians to repent; and they now called the white people to repent."

The Treaty of Canandaigua ceded Jerusalem and the settlement to the United States, securing the sect's legal ownership, but the seclusion of the settlement did not offer everything the All-Friend had hoped. There were fewer converts, for instance, away from the coastal cities, even as they regularly hosted sightseers on their way to nearby Niagara Falls, and even as the development of their land made it easier for new waves of settlers to arrive to the region, most of them scorned the religious eccentrics once there. Traveling preachers even came to Jerusalem just as the Friend had previously gone from city to city, there to save the sinners. The Methodist Thomas Smith, for one, stood outside of the Comforter's home and

declared that they were the Jezebel of Revelation, boasting later that he had brought the Friend to tears. While the women of the sect were doing quite well—more of them single, without children, and heading their household than was the case with other women of the new nation, and many of the single women living in a cluster of homes near the Friend's home— some of the men were in regular revolt, seeking to regain control of property and wealth they had given to the sect, as the numbers of the faithful dwindled into the nineteenth century. Still, life went on in Jerusalem as close to normal as it could. The Friend ate dinner privately or with a single woman companion in their room before everyone else ate dinner silently in the common room, and they taped the mouth shut of one follower who laughed too much, and when they spoke, they spoke often of fire. They continued to welcome celibates into what they called the Faithful Sisterhood, and wore strange undergarments, which they obsessively washed. And in the evening, they retired to their room, with a "looking-glass, a clock, an arm-chair, a good bed, a warming-pan, and a silver saucer," and slept.

In the end, it came down to simple things: horses, and the deeds to estates. One day, the Friend's brother-in-law, Thomas Potter, became upset that they had reclaimed a mare earlier given to Patience, Thomas's wife and the Friend's sister. When the sheriff attempted to serve a writ demanding the return of the horse, the Friend denied the document on the ground that it was addressed to Jemima Wilkinson, who was dead. Soon after, a warrant was issued against them on claims of blasphemy. They managed to evade arrest for a while, first by speeding away on their horse when men surprised them on a path. A mob later arrived at their home, but the Faithful

Sisterhood emerged from the small structure in which they made cloth, and they beat away the men with their fists. Soon after, thirty men, mainly former followers, returned to storm the home, breaking down the door with an ax. The men finally brought the Friend to court, where they were accused of blasphemy and undermining marriage, but the judges could not agree on whether blasphemy was a crime in their new state. The trial ended with the Friend delivering a powerful sermon that won the hearts of the assembled people, and they returned home certain of their absolution.

The true fracturing of the sect, however, came when Sarah's daughter Eliza married at a young age, and when her husband initiated a long and costly legal battle over the lands she had inherited. The Comforter was furious, first that Eliza would abandon the Faithful Sisterhood and marry a man, and then that this man would drain the wealth of their settlement, the population of which was fewer and fewer. In October of 1816, the legal battles protracting and settlers of other faiths clearing the land around the Society of Universal Friends in greater and greater numbers, the All-Friend dreamed of their own impending death—"that everything was cut short, that the hair was cut short, and that the time was no longer than from mid night to mid day." After that dream, it would be three years of dropsy before they actually died, but even then the remaining faithful delayed burial, and placed the body instead in a tomb they built in their basement, the architecture leaving open the possibility of life again, that they might arise.

The Friend left time, and the Friend went from here, but no death can prevent time's passage, nor the world itself, in

time. Eventually, the remaining followers removed the body from the tomb and placed it in a grave, covering it with dirt like any other corpse that rots. In the days after, the critics of the Friend published their most vicious attacks, fresh screeds in newspapers and a whole book devoted to damning their work. Most of the remaining faithful soon left the society, and the grain mill often stood still. Shortly after the start of the Civil War, the last follower died, an aged person secluded near Seneca Lake. What a silly and violent idea, to think that someone could leave the world, and in that leaving could make a new one. Don't you know? You're always making the world you live in, friend, right up until the moment you die. And then after that, too.

I try to tell a girl at a trans-centric queer party in Chicago about the Publick Universal Friend but she seems either bored or offended, I can't tell which. I rarely attend parties anymore but occasionally I motivate myself, and this party is my favorite because it's the same party I used to go to when I was young—a bus to Chicago and dumpstering some food, visiting a sweetheart I met at Camp Trans. When I first came back to this party after a decade away, there were two of these early-transition girls with the sides of their heads shaved and lots of lipstick, like a harder-edged version of how I used to dress when I was that age. Then the next month there were a few more, and they had many bracelets on and piercings through their skin. And then there were more of them, with so much purple hair (I used to have purple hair, many times) and their hair was also silver (my silver hair). There came to be so many of these girls that they occupied a small room in the back of the bar each month. Now that it is winter, I walk through that room to get my coat and go smoke a cigarette, and I have to inch between them all,

my knuckle tattoos grazing their knuckle tattoos. I hear their names, which sound like my name, or like the names of my friends. They are mad about things that once made me mad as they find joy in each other. Yet every time I try to talk to someone, we each only stutter awkwardness until I walk away, wordless at such a confrontation with age.

My relationship to who I was is tenuous. Is this true of all people? This is why it seems important to me that all people create, make art, practice their imaginations, exercise beauty. When we fill the world with artifacts of what we dreamed we begin to learn from who we wanted to be, an imagined people who might know enough to stop making the same mistakes.

Although, despite how similar these girls and I may look, how much our experiences overlap, I never actually saw myself as a woman. There was a moment once, 2010 or so, when I looked in a mirror, hacking away at my hair with paper scissors, and felt suddenly and almost mystically this sense that I was a woman. I kind of stared in the mirror for a while and felt it, this sense of self, which was nice enough, and just as quickly as that it left. I hoped after that I would have a moment like this in which I felt what it was to be a man, maybe also while I was hacking away at my hair, although this has not yet happened, and likely never will.

Isn't it strange, to grow up in a culture where your own experience is so completely erased that you don't even realize you're possible until your early twenties? If I am adding myself to the crowd of people who write, I would like it sometimes to be me when I am warm. I would like people to know that I am happy, sometimes. Like after I eat a weed brownie, and the warm

feeling seems to come up inside and fill me, the warmth even exceeding me, a gooey brownie feeling of who I am. A warm person holding someone and feeling entirely present in that moment. I would like to know: Can this offer something? To someone who is not me? Like a girl at a bar, whom I would have been friends with. Who might have meant the world to me and I to her, were the time right.

My nightlife nights are rarer because they are increasingly followed by these hangovers, the sun off the white snow brighter, more painful, than summer sun. Chicago is, of course, very icy. It's thrilling, how icy this city is. It's a city that ices with and without snow, with and without rain. It's one of those cities that just gets so cold that there's ice. I lift ice off the sides of walls and poles and fences where it has frozen and I hold the ice in my hand. I look very closely at the rough frozen edges of bark, rippled with ice. I watch the dew-ice that patterns my window. I slip a bit on the ice in my high-heeled snow boots as I carry a large vase of flowers from a funeral. I taste the ice.

The ice is also an excuse for Lake Michigan, which freezes sometimes. People are less likely to attend the lake during the winter, so my experience of it is interior, less shared than the lake of summer. The thing about the lake freezing is that I don't have any idea what its system is. It's not that it just freezes when it's cold enough, because sometimes it is surprisingly warm and the lake freezes, and sometimes it has been bitterly goddamn cold for days and the lake is liquid. And when it freezes it is sometimes only a bit, sometimes so far out that the ice keeps going, sometimes with sharp edges that invite waves to crash against them, and sometimes in blobby floating chunks and slushes. I think that by going to the lake I might learn what

this system is. It seems that to do this I will have to go there every day, which is what I try, and then, when this doesn't quite work, I try going there and writing about it. What I learn about the weird rules of the lake is that the time of day when I go there seems to matter as much as anything else, which is to say unmeasurably. The lake does not conform to my expectations of motion or fit its shapes to the rise and fall of temperature that I feel because of its expanse, stretching much farther than I can see, in many directions, with different qualities of light. Like how white ice reflects sunlight back toward the sky, so the cold and unfrozen water, inky blue, traps heat, and the vast expanses of unseen ice cool us. So really what I am measuring is not the lake but the sun, the most instinctive measure besides breath or heartbeat.

When the ice is wet enough the slush chunks rise up like gray things. Although they don't go anywhere they seem to keep rising, like a cold boil. It reminds me of how Benjy's photographs look. He doesn't manipulate the pictures digitally but instead creates images that suggest a false past of digital manipulation. This is done lo-fi, just mirrors, lights, strings, all in multitudes, all reflections of suspensions of reflections of glow. A giant rectangular mirrored tube with orange flowers like a lipstick, engorging out of its top, and the mirrors reflecting the grass and bugs and trees around it, and some sky. Or a cave, its first cavern illuminated pink and its outer edges electrically blue by the lights Benjy casts, and the pond outside it electrically blue, too, all to frame a neon sign reading *Soft Butch* in pink-and-blue cursive.

The day of the *Soft Butch* image, I remember, was unreasonably cold, and Benjy had to float out in a little boat at the mouth of

the millhouse cave and his hands were wet and the strings of lights and cameras had to stay safe. I was supposed to help but I didn't, and when he was done Benjy hung the neon sign outside my little shack with its barn windows.

There is no way to know from the image that it was such a cold day. The water there is always the same temperature because it comes out of the cave, which goes back for miles and miles. We don't go back there any longer on account of the bats. They hibernate and because of a fungus disease that is spreading across bat populations, if we wake them and they stretch their wings, that little energy expended before resting again might mean they die before spring. It's even worse if you go in one cave and then another, waking the bats and then spreading the fungus and waking more bats. If I look at the ice on Lake Michigan I can make a guess that it is hard enough for me to walk on because it is very white and geese are sitting on it—maybe the webbing of their feet is even frozen to it, as Jackson suggests over Skype, having never been in a frozen winter. "The geese will be here until spring!" I can't see how hard the ice is, anyway, or how cold. I can just see ice.

The few people who attend the Rogers Park beach in winter tend to be regulars. There are two old women who dress in the same cream outfits and hold hands, a creepy guy who is always off in the distance, some dogs. I see them all the time but we don't talk. We're just near one another. Men have always been so good at finding each other. They go to places that are straightforward: road, parking lot, bathroom, woods, park. Places where you can sit down until you find yourself a man. When I was young I spent years in those places—roads, parking lots, bathrooms, woods, parks—but it took until I was older

and finally in a city that I had my wits about me to hook up with any random guys.

Despite my early adolescent experimentation, I was a latecomer to hookup culture. Partly, because I'd always gone for the aberrant and off-tune, people with odd relations to their gender or whatever, so the older straight guys I could have picked up when I was a small-town teenage twink didn't interest me, but the weirdo faggots (and sometimes dykes!) in New York years later did. This was also a shield from a lot of violence, that I never went for straight guys, although it took me a long time to understand that distinction and its ramifications. More than that, though, I stopped myself for years from actually hooking up with anyone because I had been overcome with active, violent acne from puberty through my early twenties. It made a bloody mess of me, open pus everywhere, and it made me so deeply ashamed of my body that I would never have considered taking my clothing off in front of someone else until I was in my early twenties, when finally my chest and back were not, in my mind, impossible to look at.

I did really find it impossible to look at myself, although also I could not stop looking at myself. I'd hold hot cloths to my chest and pluck the irritated stubble out of my face, sometimes for a solid, painful hour without break. Any pressure to my skin hurt, and I would erupt in pus sometimes from leaning on a chair or bending too quickly. More than once I could not see out of an eye, swollen shut. When hair started growing on my chest and back it became even more a nightmare, bristle and grease, ingrown. I was miserable about it. All of this would be for long stretches of time all that I could think about, my face in particular, and everything I had decided I couldn't do

because of how I looked. It obsessed me, and during my teen-age years sometimes I didn't think much beyond these obses-sions: *I'm hideous and I'm gay, I'm hideous and I'm gay.* In high school, especially, the harassment, for everything—it became the encompassing framework I had for my body. So it was impossible to see myself, not because of what I was looking at, but rather because I couldn't get beyond what everyone else was looking at.

I was so greasy that I had to wash my face every few hours or I would feel myself breaking out even more. At the same time, from the moment I left my hometown, I refused to let any per-son see me without makeup, and so I was always needing a pri-vate sink, to wash myself and paint myself again. For sex, this meant I could quick-and-dirty go down on someone, and some-times a person might go down on me. But I wouldn't bring myself to kiss for more than a couple of seconds (and that only if I was having a rare clear moment around my lips), or else some-one might pull me close with their arms around me, or touch my cheek, which would be unbearable. I was too embarrassed to fuck and ask if I could keep my shirt on, but I could never take my shirt off, and sometimes I would have to say this—that I would like to keep my shirt on—because I had caved to my own desires and gone home from the bar with someone. Saying this was humiliating, and it meant I blew people, but almost never more than once, or maybe twice. I would make rules for myself: that I could fool around until someone tried to take my shirt off or reach up under it. A person I dated for a while—this charm-ing activist with a catsuit like the one the lady in *Tomb Raider* wore and who would change genders later—once opened up my trust enough to get me in a shower with them, but I only froze

once there. After a horribly long moment they drew me a heart in the steam on the shower wall and I stepped out and wrapped a towel around myself, and I remember what it felt like to cover myself with that towel.

In my early twenties the acne quieted on my body, and my face calmed down slowly, and then I became actually slutty. Just like how I had started wearing makeup when the acne came fully on, exactly as the acne began clearing is when I started slutting my way to the top of the slut class, this new me confident enough to put on a black slip and head to the Eagle. No surprise, then, that it was not until I started to take testosterone blockers that the acne actually stopped—although the hormones would also come, eventually, to mean good-bye to the hookup culture of anonymous gay men, to the bears and twinks of my youth. It had been testosterone, of course, that had been the problem all along. The doctors had tried all sorts of things, keeping me on harsh antibiotics for years, which wreaked havoc on my body's ecology and permanently damage-dried my skin. The heaves in my digestion and my horrible sensitivity to light are from those antibiotics, with their long, long lists of side effects. I am reminded of this history, the same pain intensifying every time I have to take antibiotics for chlamydia or strep or whatever.

But of course no one would have thought to tell me any of that, about the testosterone in my body being the problem. This country finds so many ways to poison people. Instead, I just needed someone to say, Would you like all of this to go away? Here is a pill to make all of these horrible things stop. And then I would have had a body that I could see and I would have loved that. I

would have had a delightful time with other twinks, naked and happy and figuring ourselves out, with my clear skin and my shriveled cock, not stressed about it at all.

Today I go to a beach a little farther away with a bird sanctuary. There's not anyone cruising, although this used to be an always-cruising place. This used to be a place where people would touch but maybe not talk, unlike now, where it starts with people talking but maybe not ever touching—those tap-tap apps. I was clinging to some anarchist ideals and using a map and a notebook instead of a cell phone for long enough that it all seems alarming to me, that there was some exchange of touch for language, of fucking for messaging about maybe fucking, of namelessness for usernames and spontaneity for intention. I know it's not that simple, tit for tap, but I don't want to give any more of my touch to language. I just want language to generate more touch.

It's the digital space, I think, that I fail to understand. I know that this is an important space, that it is real and that imagination thrives there, imagination even turns into reality there. Our human bodies can be haptic tools of whatever lives in a thriving digital space, as I understand it, and this could be revolutionary and/or a nightmare. But I think, I am fairly certain, that I was too late, even if only by a few years, to fully appreciate and live there. That this is a space I will be in awe and terror of, where language and bodies do something different.

For Simon, it was sometimes contact, but never language—our firm rule that we would never process our relationship became its undoing, each fuck verging us closer to the point where we

would finally have to talk and admit the discordance of our desires. For Jackson, as deep in the Sydney summer as I am in the Chicago winter, it's something like the inverse, with our long conversations about bodies and rebellion and power sustained by the impossibility of holding one another as much as by what we say. The epistolary or the journal, I try to have each at once.

Just like those first sexual contacts in my hometown were a game of silence and touch, of the vertiginous point between language and bodies—but never either entirely—my adult relationships aren't always recognizable as such. Recognizable to me, I guess, but no one else. I used to gather my sister's Barbies and bring them to my Ninja Turtles, placing them all on top of the Ninja Turtle Sewer Playset and acting out complex, sexualized dramas. The Barbies were often upset, and the Turtles a bit naive in their good intentions. I didn't know what the tensions were, between these women who towered over these guys, only that things were tense and that I had to hide the play. It was many years later, walking to the beach-bound bus in New York, the girls all taller than the guys, that this game came back to me like *Oh, of course.*

The distinction is between narrative and something else, between the way a town looks in a photograph and the way a town looks when you play flashlight tag in it and you are nervous. Sometimes it takes so much momentum to escape your context that you seem to never stop straining at escape after that. Sometimes you meet people you love but that still won't be enough because you won't know who you are, when you are someone who isn't alone.

Like the golden curtain for Roni Horn, the beads of *"Untitled"* *(Water)* touch just slightly.

It is plastic beads, some blue and fewer clear or white, hanging in vertical lines that collide.

The rows of blue are wider than the rows of clear, which appear white from a distance.

Like many of the candy piles, some strings of light bulbs, the curtain begins not as a set object, but as text, instructions for installation—

here, that its width should fill a space in such a way that the audience is required to pass through it,

and that the beads should be acquired cheaply, and locally.

I have not seen this curtain in person, but imagine the feel of the beads against my body, the movement of the beads (waves), and the plastic clatter of their collisions.

Like just softly, all of me is touched, and I hear it.

Water is a bit like the moon, in that if we are not careful, it will accumulate our ideas to a measure that obscures it.

To even place them together—

the moon, at dusk, reflected on a pond,

or the suspended water of a cloud obscuring the moon—

is to suggest a deep, almost selfish romanticism.

Such romanticism is pleasant, and I have spent many nights on a Brooklyn roof or a Tennessee hillside gazing at the moon and thinking of someone I loved.

Sometimes a person far away, sometimes sleeping in my bed.

The moon has a partial face, trapped to look at us just so, and another face, always looking away.

This is why it is different than water.

When has water ever remained the same?

Gaze across the lake and see if you can find me.

Move through fog until we touch.

Here, my hair is wet with rain, and the white cotton of your shirt see-through to your skin again.

Simon and I finally go to Berlin for the summer, my first trip outside the United States, sparing a visit to Toronto with my high school marching band.

A job writing multiple-choice questions for textbooks lets me travel, working extra hours to save, my life mobile.

Are Simon and I in a relationship? A: Yes B: No C: Maybe someday D: All things exist in relation

I always leave as many "none of the above" and "all of the above" answers as the style guide allows me.

Before leaving, we browse through apartments to sublet on Craigslist and think of location, think of space.

We decide on a place near the Oberbaum Bridge—a whitewalled unit overlooking a courtyard, one bedroom and one living room, everything about it spare.

When we leave, Simon takes a different flight than I do, and I cross the border alone.

It is an awful, shameful thing, the violence of its doing and what it means,

and when I cross it a headache comes on, stays with me.

Simon is hours ahead as I lean my cheek on the airplane window and try to detect whether I can feel the change in temperature from which it keeps me separate, or whether I am just feeling plexiglass.

Although I know I am in the sky, and that the ocean is beneath me, I can't see beyond this small, dark reflection of my face.

This is probably the farthest I will get from the earth, I think, and I am bothered by having thought it.

To receive the key to the apartment, Simon and I have to go to the café downstairs and speak to someone there, someone who expects us.

This is all very romantic, I tell myself, as we sit at the café, and as we take our beers into the street and wherever we may care to take them.

What exactly I find romantic about waiting for a key and drinking a beer, I am not sure.

After we unlock the door, we throw our bags onto the tile floors, and he begins arranging the furniture of the living room into a second bedroom.

I feel rejected, as two nights prior, in Brooklyn, our bodies had fit together as they always do.

How absolutely silly that we name some things as romantic, some as not.

I have spent many afternoons waiting in cafés, impatient for something to occur, or for the day to become different.

I could not recognize a single key from my past were I to see it now, despite holding each of them daily, despite each being so necessarily unique.

Simon and I quickly leave the apartment again.

We find a park where we smoke, and later, a small bonfire by the river.

It is late, although much earlier for us.

We approach people with our awkward German, and they reply, again and again, in English.

As at home, my intimacy with Simon in Berlin is ineffable, not in that it cannot be said, but that in being said it would then cease to be.

This is true whether we sleep in one bed or two.

This is true as he links his arm in mine and we walk our way back across the bridge, its two spiral towers and the countless padlocks fastened to its gridded rail by people in love.

The shape of the moon's orbit, an ellipse around our own spin, means that we glimpse the edges of its far side but never catch more than 59 percent of its surface.

At its closest point to the earth, it slows, and we can see a bit more of its western side,

while at its farthest point, it speeds up, revealing more of the east.

This subtle movement across that 59 percent is called *libration.*

Similarly, we exist not at the earth's center, but rather on its uneven surface, each space unique to us,

and each affording an imperceptibly different view of the moon.

The movements and geometrical quirks of libration are similar to the movements and quirks that bring the seasons.

I for years believed the moon was responsible for the tides, for instance, but know now that a combination of sun and earth and moon as moving bodies,

gravitational pulls in all directions, and the shapes of ocean floors,

all of this and more is at play in moving the water.

The moon is just a thing near some other things, a complicated thing to be.

It's so close you'd think it would touch.

Because the strands go quite literally up and down, one of the easier reference points for *"Untitled" (Water)* is a waterfall—

the blue and clear beads that look like they fall whenever someone passes by.

The piece also offers an occasion to think of movement, water, and crossing in relation to the artist's own life,

having been born in Cuba, sent with his sister to Spain in 1971, and relocated again to his uncle's in Puerto Rico before finally moving to New York in 1979.

His parents and two of his siblings would escape Cuba shortly after that, during the Mariel boatlift.

Or perhaps some of the water he included, along with these relocations, in a 1993 version of his portrait,

a recurrent piece that lists autobiographical phrases with years—
1964 Dad bought me a set of watercolors and gave me my first cat, and

1991 Jorge stopped talking to me, I'm lost—Claudio and Miami Beach saved me, and

1990 silver ocean in San Francisco.

His personal correspondences are also wet with the stuff.

"Never thought that a natural element, such as the falls would generate such an incredible array of fetishisms,

Niagara cups, belts, lanyards, key holders, etc."

he wrote to a friend after viewing the Falls.

"Well it was OK,"

Ross added to the note,

"but they weren't as big as I thought they would be . . ."

Or maybe, like his autobiography, the water is just that—

waves of itself, lapping body and land.

Sung, inside a body again.

And then a body, singing of land and water.

Simon and I acquire two used bikes, a small girl's bike belonging to a friend, and a matching adult bike purchased off Craigslist.

The owner of the Craigslist bike turns out to be from the U.S., and in only moments we connect her to a mutual friend, now living in Los Angeles.

Both Simon and I being on tight budgets, the bikes become our cheap access to the city.

The arcs of our rides expand, concentric to our apartment, and so we see more each day of the way Berlin holds its history.

Those of my ancestors that I know of were all German, which gives me a vague sense that maybe there is something I could learn by paying attention to these particular horrors and liberations,

to keep my eyes on the patterns.

We come to frequent a bar with pink fur walls and another with a sex maze in the back.

We decide the bar with a sex maze is sailor themed and refer to it as such, although there is nothing particularly nautical about it, just men there.

One night, Simon picks up a giant of a man at the bar and, too drunk to steer his bicycle, makes the man ride it back to our apartment with Simon perched on the handlebars, laughing the whole way.

Simon is good at the map, but I learn places in relation to one another.

When I am alone I might find my way by memory from an art gallery to the sex club, or from the sex club to a squat, yet finding my way from the art gallery to the squat remains impossible, unless Simon goes on that ride with me.

Because of this, when he goes to visit an ex-girlfriend in Brussels for a few nights, I find myself stuck in only familiar places.

One evening, I follow a stranger, a dancer, to a new bar and am relieved that he agrees to come home with me,

embarrassed that I would otherwise need to backtrack to our first location of the night, the opposite direction of my sublet. Returned from Belgium, Simon tells me of the sex he had with his ex, and I tell him of the awful sex I had with the dancer, who seemed only to sit there with his jaw slack, yet moaning. Later that evening, he and I get drunk enough that we seem to blur into one another.

Riding around, I spontaneously manage an entire sentence in German when he tilts off a curb and I announce:

Der Mann auf dem grünen Fahrrad des kleinen Mädchens ist gefallen.

We walk our bikes and steady one another, our speech rapid and simultaneous.

When we return to the apartment, there is a note on the door, its German requiring a dictionary to translate.

Where have you gone? the giant man asks.

I would like to see you again.

The first image of the moon's far side came to us on October 7, 1959.

It was taken by the Luna 3 spacecraft, a Soviet mission led largely by Soviet scientists.

For decades prior to this, the Soviet space program had been propelled forward by German scientists and German research seized by the state at the end of the Second World War.

Mond, the moon is called in German, one of the languages of the world that make it masculine.

Luna 1 had missed the moon by miscalculation, and Luna 2, successful, was the first human-created object to reach the lunar surface.

On receiving the images from Luna 3, scientists recognized two mares—

expansive, shaded plains created by volcanic eruptions.

Two was a small number in comparison to the many mares
of the near side, which humanity had always seen and often
mistaken for water.

They named one *Mare Moscoviense,* after Moscow.

The other they named *Mare Desiderii,* after dreams, although
they would later come to realize those photographs were of
poor quality,

and that it was actually an even smaller mare surrounded by
craters,

the dream never actually there.

The existence of so few mares was a surprise, as were the large
number of mountain ranges that filled the moon's unseen side,
so unlike the side we knew.

People often refer to this far side of the moon as the dark side,
although it receives light and darkness in equal measure to the
side we see—

two bright weeks, two of night.

There are fewer mares, anyway, not because our own planet
shields the visible side from space debris with its mass,

but likely because the heat radiating off the earth changed the
composition of the moon in its first days.

One of those times, when it just takes a little warmth to change
everything.

The Berlin apartment is a long corridor that runs along the
kitchen, then the bathroom, and then the bedroom,

all facing the courtyard, before the corridor ends by opening
into the living room.

While there is no door to the living room, the foldout couch
on which Simon sleeps is positioned outside the line of sight
from the hallway, affording privacy.

My bedroom has a door.

In Brooklyn, Simon's apartment is more of a cluster, with the kitchen and bathroom to either side when you enter, then a living room with three bedrooms off it.

Simon's bedroom is the smallest, but his bed is large, and we are comfortable there both with and without the door open.

"Who knows what you two do behind closed doors," my friend Mona jokes on multiple occasions.

I always insist, *Nothing,* although I can never find a way to make it seem believable.

Only rarely do we say that we love each other, but when we do, it is as we lie in each other's arms, which we do every evening, as of late.

In Tennessee, I have only my small shack.

It is one high-ceilinged room, one porch with old barn windows for walls, and an unadorned deck, all the same width and in a row.

I find hanging doors to be one of the most challenging parts of carpentry.

A door is heavy and very particular about how it might fit snugly into a frame.

The door in my house hangs unevenly on its hinges, and its latch does not line up properly, hitting the strike plate instead of clicking into place.

You have to slam the door to shut it, which I never do.

I just feel the breeze across the deck and through the screen.

"Untitled" (Water) came the year before Felix Gonzalez-Torres died, the last curtain after *"Untitled" (Chemo), "Untitled" (Blood), "Untitled" (Beginning),* and *"Untitled" (Golden).*

There are slight references and happy suggestions across these works, reasons to find joy in them.

There is his golden friendship with Roni Horn, the warm reference to bodega curtains.

The words in the untitled works of curtains are all words of life, in one way or another.

Friends and colleagues always called Felix Gonzalez-Torres *generous,* that description humming through interviews and recollections.

And it's true, the curtains are generous, they give more than enough.

They work to undo the institutions that procure them, forcing the owners to go and buy some cheap beads,

just as other pieces require owners to give away, endlessly, what was just purchased—

paper, or candy.

Even with the billboards of the beds, the artist himself would retain the rights to the photograph,

as the collector purchases only the right to distribute that image, to proliferate it in endless variations, to rent another billboard in another place.

And shouldn't those things be free?

Medicine, water, blood, the goldenness of something beginning, for whoever might need them?

One day, when we arrive to the sailor-bar, we find out that someone had been murdered in the sex maze the night before.

This brings on an awful series of attraction and repulsion, which we talk about for days, exchanging horror stories of our sexual undergrounds,

eroticizing the things that try to kill us.

There is something specific, also, about the giant man coming to our courtyard, more so than if we had offered him a street-facing door or steps descending into an alley.

Perhaps it has to do with the windows facing inward, with the public intimacy of the display.

"I work all day like a monk /

and at night wander about like an alleycat /

looking for love,"

Pasolini begins one of his Roman poems, written early in his relocation to that city.

The filmmaker and poet had fled there after being caught with teenage boys, hiding in the trees,

a scandal exaggerated to cost him his teaching position and drive him from the Communist Party.

For Pasolini, Rome was a chance to reinvent himself, a necessary prospect.

In Rome he could write novels and face the self that existed in this new place, which could be neither "an old nor a new Pier Paolo."

"I pity the young fascists,

and the old ones, whom I consider forms

of the most horrible evil, I oppose

only with the violence of reason."

he writes in the 1964 poem, and describes himself in its closing—

"Passive as a bird that sees all, in flight."

It is a poem of confronting, not just the mobs that condemn and disparage his sexuality, but his own actions as well,

the contradiction of feeling both hate and love at once.

Which part of it might have appealed to Gonzalez-Torres,

when he selected the poem for the press release of a 1995 show at the Andrea Rosen Gallery?

It is placed alongside an excerpt from Barbra Streisand's 1995 speech, "The Artist as Citizen,"

in which she defends both abortion and gay rights,

and an excerpt from Rimbaud's "The Savior Bumped Upon His Heavy Butt."

"The Citizen as Artist" might be another way to say it, to acknowledge that we are making something by joining together.

I suppose I can pity the fascists, sure—

I know how painful it is to be defined by something so large that it seems to swallow every bit of who you are.

That's why feeling joy is so revolutionary.

So that later, when I feel like I am a memory, all alone in the moonlight,

I will know that I must wait for the sunrise,

and I must think of a new life,

and I mustn't give in.

Simon must know my disappointment at our separate bedrooms, but we offer each other the generosity of leaving this disappointment unspoken, too.

Over the past years, I have selected readily available explanations for the *why* of these periods (a year one time, more) when our touch isn't sexual and we are not quite together— the long weeks of mending bones following a bicycle accident, for example,

and there was always the fact that we both loved other people, too.

Mainly, however, I just remind myself that I like this,

that what matters is that we're together.

I used to think it was a horrible idea, to move somewhere new as a way to escape your problems.

But now I know that sometimes you can run, that sometimes you can get away, so long as you keep your mouth shut.

Simon makes a plan to visit his ex-girlfriend in Brussels again, leaving Berlin the morning before I do.

Our last night in town, walking down the bridge, we joke about taking metal-cutters to the padlocks so each would drop to the water below, a plunk.

When I return to New York, I am exhausted and broke and find that my phone no longer works.

I leave my bags at Simon's Brooklyn apartment and borrow a few dollars from a friend to get to the beach at the Far Rockaways.

I love this beach because I know that I can go alone, and that there I will find several friends.

It's very important, I think, to keep going to a gay beach, because that way people who are strangers to you will be able to meet their friends there.

Off the bus I am immediately high and naked, stepping into the cold water until it reaches my hips, the rise and fall of water obscuring and revealing my shaft.

People give me things to smoke and sugary alcoholic drinks in little plastic bottles.

I walk back and forth, to towels and to lapping waves, rinsing the sand off my feet and stepping again in it.

Touching the ocean I think how far away I was yesterday, and now I am here.

I see the moon, luminous enough to be visible in the day sky, and realize that I could have stayed, rather than returning to this place.

When I am exhausted, I enter the water once more, dunk my head, and begin to find my way back to Simon's empty room.

I get lost on the wrong bus, then wander around the neighborhood with my sunburn and sports bra before collapsing, finally, in a bed that smells of him,

and I suppose of me, too.

Nearly everyone I know relies on sex work to pay their bills, to one degree or another, although I rarely mention this in my writing, and so my essays are filled with people who have these lacunae in their lives, their behaviors and movements and circumstances seeming to lack a certain context or motivation, and their labor erased. I worry they come across like bullshit flaneurs or something, like they have resources or stability they don't, when the reality is that they are all activists, artists, survivors, finding ways to live under and to fight against a state that tries to legislate our lives away.

Not that everyone who looks like a bullshit flaneur is all bad. A lot of my favorite books are filled with really wonderful queens acting atrociously, pretty much all drunk and some of them revolutionaries and some of them just absolutely ridiculous and in love, these faggots with *so much* over-the-top, entering the room style-first. Everywhere you turn, it's just so wonderful—you can learn the world from the people wearing the silliest clothes.

Jackson and I make plans for him to return to the United States, to reconnect. If we decide we want to stay together, then when it's time we can get married and he can stay here, is the plan. I make this plan because I love Jackson and I want to keep being with him—not for the rest of my life because who could make a promise like that, but at least for a while. "I am reasonably confident this will go fine," I keep telling my friends, proud that I've homed in on something that sounds so logical, like I've found a way to calculate myself straight into a romance. And anyway, if I don't care about marriage, it's hard to think divorce is consequential.

Grades submitted, I throw some rompers in a bag and catch an early flight to LaGuardia. A couple of days later, Jackson flies in

from Sydney, drug-dazed from his going-away party. He is as handsome as ever in his button-down travel outfit and with this look like he's getting up to something, and I am as happy to see him as ever. Jackson has always made me feel beautiful, from the first moment he laid his eyes on me, and so he has only ever seen the version of me who feels beautiful, who beams with it. "Clutch Tammy," he says, my whole name coming out of his mouth, "you're so beautiful," and just like that we're two people smiling in an airport.

Lately, I have been thinking a lot about two people next to one another. Who is next to each other, for instance, and why are they next to each other? Or why not? That sort of thing.

I talk about this with Jackson, keeping the obsessive chatter of our Skype conversations going in person. I talk abstractly about what being next to each other means, as we ride the train into Manhattan one evening and then later as we lie around in bed trying to fall asleep. Who gets to be next to each other, and who does not get to be next to each other? Most often I'm talking of the concepts, broadly, or specifically about someone else, but also thinking of myself. As in, who am I next to today, and should I be? Does this make us a coalition, and if so, what for? I think these are good questions and appreciate being aware of who I am next to in ways that I might not have been otherwise. I think it's important especially because I have noticed it can sometimes falsely make me feel safer if I don't notice people around me, rather than if I do. Like ignoring as superpower, like I didn't notice you threatening me so it never happened. I find there is more pleasure in noticing anyway. An example is that one evening, after taking drugs, Jackson and I end up on the Upper East Side at three in the morning with this woman who

lets me try on a studded leather jacket from some famous music video, I forget which one, and I never see her again. Another is that Jackson and I went to the McDonald's at sunrise after that, and while Jackson uses the bathroom, I am next to the only other person in line, an older woman in a red jacket who smiles at me twice. Stuff like that.

One of the reasons I'm thinking about this is that I'm not supposed to be next to anyone, in the sense that I never knew people like me existed, so I never imagined myself next to someone or not. Being a person next to someone feels precious, especially while so many forces in the world work with such violence to make sure I am not next to so many people, and although it is violence, also, that brought me here in the first place, that is why I am next to who I am next to. One night I ask Jackson to make me a list: Why aren't we supposed to be next to each other, he and I?

> 2 good?
> You're not the next to type
> We both prefer mine on top of yours
> V. modern and unknown and really breaking all the rules to have collaborated with these bodies in the first place let alone to bring them together
> Because you're playing pool and I'm having alone time

And so now we're next to each other, place to place. He and I take a bus down to Tennessee to visit our friends before we go to my new home in Chicago. I show him a long poem I wrote about him and he cries a lot, and for a while every time we start to have sex he gets overwhelmed with emotion and cries, so for a while we don't have sex. A lot of things are different from last

summer, such as his girlfriend broke up with him and I am now living in a new city, with a new job and some new friends. But for now we make ourselves a little room out of the screened-in side porch of Benjy's flower patch of a house, with a thin mat for a bed and an ashtray for Jackson to fill, and we settle into a routine of catching up.

Staying for a bit on Benjy's porch (*where we fell in love,* Jackson and I keep saying) means that Benjy and I get to play around with our art some more. He returns one afternoon with new flowers from the greenhouse where Sterling used to work, and I arrange them into letters, one at a time, arranging and rearranging the little plastic planters while Benjy snaps overhead photos from the roof. The series of photos spells out *MY EXIT.* It's a quick process, just an afternoon between Benjy's fleeting thought—*these would make pretty letters*—and the photographs. If my own exit means something new is growing, that seems pretty optimistic, especially if the new thing growing is all flowers and stalks and the suggestion of spring turning into summer. Like maybe if the climate change gets us before we have a chance to totally scorch the earth, other things will still get to live and evolve here, the water planet of the octopus people and their friends, the wise dolphins. We imagine the series of photographs as an answer to the question, "Is the rectum a grave?"—a sex joke about life, to suggest going elsewhere.

Jokes really are most of it, for Benjy and me. Our conversations are filled with laughing, as is most of our time working on the art. A good laugh is most of what it takes for us to find meaning, in the way that two people can always make their own meanings. A favorite joke lately is the idea that the art is going to make us rich, that we'll finally be wealthy, wealthy

artists, instead of tax dodgers, underemployed in our temporary employment.

"Hello, Mr. Moma? Yes, you can have these photos for thirty million dollars," I say.

"For you, Mrs. The Guggenheim," Benjy answers, "the sculpture will cost double that."

I decide to head into town to get some supplies and also some drill bits, because I lost Benjy's helping a friend down the road rebuild her porch. It's about a twenty-minute drive on curving roads through thick trees and ferns and weeds so overgrown you can't see around any of the bends. Jackson climbs into the truck with me and on the way we stop at the farmhouse Otelia rents. There's a barn with a giant cow painted on the side and a rundown shed that leans to the left, what's left of a general store that operated in the 1940s. The house has a big wide porch out front and whenever I stop by a large sheepdog named Mommy runs out to greet me with her nasty clumps of ratted white fur and a tick or two bulging gray with blood around her ears. There are some other friends visiting and when we all talk I think about the people shared between us who have died over the past couple years, how all of them knew some of us who are here but in different ways, and did they all know each other, which I can't remember for sure. Jackson rolls a cigarette and starts to pet Mommy while I peel off my T-shirt, so worn through that the point of a nipple is visible, and add a sports bra beneath it.

When I'm in a rural area I make a distinction between town clothes and regular clothes. Town clothes are for when I go into

the little cluster of groceries and fast foods and hardwares that are down the highway a bit. Years ago, when I was first starting hormones and living here, that distinction wasn't much. I wore tattered jean cutoffs and a T-shirt most every day, and my breasts were little nubs—even if people saw them, most didn't have the context to know what they were seeing, especially because trans people weren't all over the TV yet. I was pretty set with this dykey look for a long time, wearing my hair in a mullet and running my only pair of black boots flat before finding some new ones at the thrift. Most people just figured I was bad at being a faggot, which was better than nothing, as far as that goes.

Not that I'm the first person to fail at being a faggot in this region. There's a gravestone just a few miles from the hardware for Hiram Kersey, who went by the name "Pomp." Pomp joined the Confederate Army when he was thirteen, but as the Union advanced, he returned to his hometown, forming a small gang to raid, rob, and murder Union sympathizers in the region. Local histories describe him attending a series of late-night dances at a particular barn, parties known for their "rustic beauties" and strong alcohol. "Beardless Pomp Kersey is said to have attended one of those dances dressed as a girl and to have danced with his arch enemy," one history has it. In his regular clothing, he returned to the barn an evening in 1864, firing his rifle into the party. As he fled, that arch enemy-cum-dance partner tracked him to the gang's hideout, where he came upon Pomp and a male companion in their sleep, and shot them each dead.

It's easy enough, sometimes, to hide, to blend into a crowd and let everyone pretend that we're the same. Easy, too, to buy into the fiction of it myself, to forget that the person who puts on a dress in the barn is just as likely to turn around and shoot me

in the back as anyone else. Sometimes an anonymity like that can feel safer, like when the cashier at the grocery or the hardware would confuse me for one of my similarly weird-looking friends, asking how someone else's dog was recovering from a rattlesnake bite, or whether someone else's neighbor was home from visiting her daughter. It felt nice, in a way, to be untraceable, a vague someone else. It felt like the fall I was thirteen, when I refused to wear anything except one of five Champion sweatshirts in similar greens and browns, as though I could stand against the changing leaves of the woods outside our school and no one would notice me, or who I actually was. But whatever the pleasures of anonymity might be, the horror of actually disappearing, and drifting away into the quiet, white violence of it all—that was motivation enough to get me out of the Champion sweatshirts.

There's not much shade in Otelia's front yard, and the summer in Tennessee is incredibly hot. The air gets thick with humidity in a way it didn't seem to by the Great Lakes, and I always feel like the constant sweat on my body is radiating outward, merging with the wet air. The whole earth comes alive with the summer, almost painfully, bugs everywhere, and everything is this kind of green that I had never known before, either, a green that shines. I feel the heat bake onto me, like it is more than I can handle, as the earth around me overflows with living things.

Otelia sits in the middle seat of the truck and Jackson sits in the passenger seat. With the windows down and the swerving roads I put my arm across the back and squint into the sun, reflecting off pavement, until we reach the lumber supply, where I buy three big pieces of insulation that are silver boards. The sheets

are made reflective not to reflect sunlight back outward, exactly, but to prevent radiant heat transfer. People put them in their roof, which is more often between people and the sun than the walls are.

Otelia and Jackson help me load the sheets into the back of the truck, smoking cigarettes and being sweet together, laughing and all that. The guy at the lumber supply always used to ask what my projects were and then I'd tell him what I was working on and he'd sit there at the counter with me while we drew pictures and talked about the choices I was making. He'd tell me especially when I could save some money and he'd also tell me when he thought something might be out of my skill level. I really struggle with spatial visualization and remembering the language of carpentry, and sometimes my mind would empty when I talked to him, and I would just pretend I knew what we were saying. I've been gone long enough that there's a new guy working, though. He's fine, like he doesn't pretend to like a thing about me, that scowl and all, but that's okay because it means he doesn't ask me what I'm doing with the sheets. I'm always flustered to explain myself when I'm using carpentry material for some gay art project instead of whatever it's intended for, when I need concrete blocks to elevate the altar to our dead pets, or like now, when I just need to get some insulation to flash the sunlight where I want it to go.

Which is what I do, two people being sweet together and helping me carry the floppy sheets to the truck. The sun coming off the silver feels hotter than the sun in the sky because the reflected sun is closer to our bodies, and maneuvering those sheets around is a game of staying in the insulation's shade. On the drive back to where Benjy lives I can sometimes see a little

of the hill or some green and blue across the silver but mainly it's just glare, a pain spot I can't look at to see.

We set to work arranging the sheets and mixing up a batch of green liquid for the next step in our *Squirt!* sculpture. It's a straightforward idea. We're making giant letters out of Squirt cans (like the soda) to spell out the word *Squirt!* in a 3-D sculpture, as high as my shoulders and as thick as my breadth. Then we're mixing together this liquid that we're pretending is Squirt but is actually just green food dye and water and corn starch for viscosity. Today, we're throwing giant buckets of that liquid against the backdrop of hillside and sky, huge splashes of green viscous liquid looking unreal, like a waterfall went backward and extraterrestrial. The insulation is to reflect the sun back onto the liquid, so people can see what it is better. Once it's all done, we're going to print the giant splashes of liquid onto a large industrial vinyl sheet, then grommet it above the sculpture, so it looks like the Squirt cans are squirting Squirt into the sky. It's called *Squirt!,* with the exclamation point.

Benjy and I spend a lot of time laughing about *Squirt!* "See," we say, "it's called *Squirt!,*" and we usually crack each other up while our friend sits there and maybe politely laughs. We sometimes say it at the start, "So it's called *Squirt!,*" and sometimes one of us waits until the very end and says, "and it's called *Squirt!*" landing like a punchline we'd never heard before. For example when I tell Cyd, who I fisted with the pearls and all that, about the piece we get into a back and forth, him saying he doesn't understand what I'm talking about and me insisting there's nothing to get, it's just about Squirt. "Alright," he says, unconvinced. After Benjy realizes how expensive it will be to get all the Squirt cans we need (hundreds, it turns out, and like a dollar each with the Squirt in them),

I start placing ads on Craigslist, offering to let people see my tits or touch my feet for Squirt cans. I get back streams of emails, but all either thinking I mean "penis" when I say "Squirt can" or offering me, ridiculously, other kinds of soda. When Benjy and I really get going we talk also about a companion sculpture. It will be a fish tank filled with bright pink liquid, and inside it we're going to hang a neon sign that says, *Do you have to let it linger?* in curly cursive, and we're calling that one *Cranberry Squirt.* Usually by the time we get to revealing the name we're laughing so hard that we're tearing up but that doesn't mean we're not deadly serious. We take our joy very seriously, our deadly serious joy.

One of Jackson's dates comes and picks him up and takes him away in a truck. While Benjy and I are working, we use the reflective sheets to take some portraits of ourselves, too, but the sun is so hot I have to keep running back inside to stand in front of a fan so my makeup doesn't melt off. When we're done we give the sheets to our friend to use on the house zie is building down the road, which means the silver will be all about preventing radiant heat transfer, as intended. It does feel off to use a lot of resources to make a piece of art, as we drain the earth so fully that our vegetables barely contain nutrients and our water runs dead plastic. Like I go to the museum and half the time I think *fuck you.* So it's some comfort that the insulation will go to a home, and that our friends keep drinking Squirt, can after can after can. There's value just in being happy, I know, in laughing so hard we're crying when we say "Squirt!" for the tenth time that day, liquid just running down our faces and liquid thrown up at the sky like an exaltation, liquid gushing everywhere like you wouldn't believe. Squirting.

Jackson and I get back to Chicago deep in the summer and start to figure out what kind of future we might make together. I don't

have a bed, just a mat on the ground, and he sleeps with me there, the curtain blocking us from the rest of the house, or sometimes he sleeps in the hallway closet, where he has his own mat. In the mornings Stevie wakes up bleary from habitual NyQuil usage and we all brush our teeth. We go to the beach a lot and I even unretire from the nightclubs because Jackson likes dancing. I put on silly outfits and everything and drink cocktails, so I plan for a split-head nausea and podcasts with my eyes closed the next morning. I stop going to just the ice cream shop near my place and go to a few new ice cream shops with him, one of which has a giant ice cream cone out front, and Stevie takes a picture of us in front of it. Everything is relaxing and nice. Because he's looking to move here, Jackson hires a lawyer for an hour to talk about immigration stuff, and the lawyer says that if we're considering getting married we should do it in the fall, that if Jackson leaves the country with his visa as is, he probably won't get back in.

We sit down to decide, well, what do we do? Jackson goes to the beach to think about it and I get really high out of my potato. I try to call a couple of friends but no one picks up so I get high out of the potato some more and walk to the thrift store, where I buy more sports bras. I get home and none of the sports bras fit; they're all painfully flat. Jackson gets home. "I guess that seems fine," I say, "but I'll break up with you still if it doesn't work for me," and he says of course, that's a given. And so we decide to see what marriage is like.

"I don't believe in marriage" and "I am getting married" are a confusing contradiction. Marriage is illegitimate and structures resources unjustly—it should be abolished, along with the state in general and especially the military and the Justice Department, and land should be repatriated to indigenous people. Resources

structured through marriage, such as health insurance and the right of movement, should instead just be given to everyone. For years I was surrounded by people who centered their politics on a deliberate antimarriage stance—a queer generational quirk—and I maintain that stance, although I find myself now extending those institutions by engaging them, continuing this colonial practice by moving a white person here, violating what I believe. It's unnerving, and I have no answer for it, this binding of my relationship with Jackson, which I love, with the ongoing violence of the state, as he and I move in together, and as the legal entity Thomas heterosexually marries the legal entity Jackson.

It is a particular thing. Me, a person who really likes having flings, which usually last two to four weeks, at most a whole summer. Him, a guy who tells people that he loves them way too early. Just a couple of romantics, I guess, if that's worth anything these days.

First Jackson and I move into a new apartment, then we fill the apartment with flowers and trash furniture he finds in the alleys, then Otelia and my mother come to town so that we can take pictures of getting married for the government. It's a rigamarole where Jackson makes onion tarts so everyone can eat and where I run around the apartment hiding things I don't want my mom to see like I'm a teenager. Sometimes I yell "Bridezilla wants a coffee!" or "Bridezilla wants weeeeed!" in my deepest, gravelly voice, wearing out the joke way past when it is still funny. I do cry a little when we go to the beach and say that we love each other and take a picture, but that has nothing to do with marriage, just with standing on the beach on a beautiful day with Jackson while my mom stands there surrounded by transsexuals and sees me happy. She's a retired school librarian, and she always let all the closeted

gay kids and troubled teens eat lunch in the library with her. I'm sure, however, this is the first time in her life she has been surrounded by people like me, instead of me and some freaks around people like her, and although I want to ask about it, how it feels, I like it better if she doesn't have to talk about it and can just have a nice day. The sky is really blue and she stands next to Otelia, who wears a one-piece bathing suit, barely containing her business, and next to Stevie, with a floral shirt. They smile at each other a lot. When the ceremony/photo shoot is done some more of our friends come by, chatting and swimming, and my mom goes out in the water. She swims back and forth, back and forth, and keeps going, the last person swimming after my friends begin to leave. She's so happy, swimming on this bright day, with some people I love and then just her, swimming, which I guess makes the ceremony/photo shoot worth the effort, if two people being in love means that someone else swims.

When I dance I like to dance alone.
I like to dance on the bare floor beside my bed or,
if I am outside the city,
on the flat ground of a yard or hollow.
I like to dance with my headphones on, dancing to something sappy like "Linger" by the Cranberries or Joan Armatrading's "The Weakness in Me."
My dips and splays are like I am reaching so far that I bend.
You might think they lack grace, these moves, but that is only because I like to dance alone,
the grace of my movement known just to me.

For five unannounced minutes a day, there is a dancer on *"Untitled" (Go-Go Dancing Platform),* but most of the time there is no one, just the square and pale blue platform.

Plain light bulbs make another square, ten or so equally spaced in a line along each of the four top edges of the box.

So when there is a dancer on the platform, that dancer is within a square of lit bulbs.

Encountering the piece, there is no instruction or schedule to indicate the dancer will come, eventually.

Rather, the dancer arrives—

a metallic speedo and sneakers, and a Walkman playing some song we don't hear.

The dancing is kind of rhythmic, reminding me of the go-go dancers in Manhattan, men stepping to the side and hips and shoulders.

Sometimes the arms go up, and then they go back down.

The piece first went on display in 1991, as part of the show *Every Week There Is Something Different.*

The performance begins and ends when the dancer is on and then off the platform, but again, most of the time the platform is empty.

It is a blue square rimmed by light bulbs, and the audience leaves the room knowing it to be just and only that.

Simon and I go to the Cock in Manhatten for their all-you-can-drink night.

These are our last weeks in New York together, as we have decided that Seattle will be our future.

"We haven't lived in Seattle," we say.

We pay ten dollars at the door and get free well drinks all night, tequila after tequila.

The Cock is a tiny space, with the go-go dancers on the bar and tall round tables with stools along the walls.

To dance you have to awkwardly claim a space in the middle of the room, where hands keep touching everywhere.

My movement stays vertical, my feet and shoulders doing most of the work, although the music is so bad I'm quickly back to the roped-off bit of sidewalk where we smoke with our friends. In the back is an area we call the back room, which is just the back of the bar, no walls to mark it off.

It seems like every time I go to the Cock someone tells me they had to shut it down recently because the health inspector found chlamydia on the bar.

"Why were they testing the bar for chlamydia?" I always ask, but no one has an answer.

"Because it's the Cock," someone tells me tonight, in the back room.

I go down on my knees and my head is spinning as I open my mouth to the men and someone else puts a key under my nose.

I see Simon in the tiny space where everyone is dancing, smiling, his hands in the air.

I see someone else on the dance floor, crouching so he can suck a guy off without having his legs splay in everyone's way.

I lift my hands a little in the air and start to bounce, like there could be dancing here too, and the leather man turns away from me.

Simon goes home with a guy he'd met before, and somewhere between blacking out and morning I find myself in our bed, full of bile and pain, hungover as much from the cigarettes as anything else, still tired after a night.

I am surprised to learn that Gonzalez-Torres doesn't specify a gender for the dancer, and that the image I have formed has been made a man by me.

Were the go-go dancer announced somehow, perhaps their arrival made explicit in the title of the piece *(with dancer),* the platform would be otherwise empty.

But unannounced, that space is always complete as is, lit.
It's a very exciting moment, to wait for someone to arrive,
to give you pleasure by giving themself joy and pleasure.
How many people can this person be?
Can this person be more, somehow?
But the piece is another kind of reversal in Gonzalez-Torres's
work, a tease like maybe some go-go dancers try to be, too.
You take the candy and eat it, and you fold the paper for home,
and you walk through the beads, but can you tip the dancer?
Can you reach your hand out, and if you do, will he take it?

When Simon does dance, his dancing brings a specific smile
to his face, and so I have a specific smile on my face, too.
Part of it is that he is most likely to dance when we are out
on some sort of adventure into nightlife, high and with our
looks on.
I saw him dance in bars to music he didn't like and very rarely,
maybe a few times, when some reason had made the occasion
right, in the bedroom or living room of where we were.
He smiled and moved his hand a bit up in the air, maybe,
and his left side would move forward and his right side would
move forward.
I have made him dance with me a couple of times, too, once
to the song "Kiss Me" from that movie where a nerdy art girl
gets a makeover and dates Freddie Prinze Jr.
In Brooklyn, the space at the foot of the bed is just enough for
us to step back and forth with my arms around his shoulders.
I know he hates it, at least a little bit, but he indulges me, I
assume because we love each other.
Okay, he says, one of our last Brooklyn nights and stumbling
our way home from a leather bar where we had been playing
pool.

Stumbling home and we link arms,
and when we are back he moves his hips for a minute in that
way and I fall asleep smiling.

The spare nature of Gonzalez-Torres's art is not just an oppor-
tunity to face the power of our own imaginations,
to extrapolate what we will from the taste of a candy,
but also an occasion to honor that part of the artist's life that
I'll never know.
He makes something of his desires, but that does not grant us
any right to those desires,
only to the specific thing he has shared with us.
You can't touch the dancer.
Why did you think you could?
Who told you that you have that right?
Just love people for who they are, and for all the things they've
chosen to keep away from you.

Although Gonzalez-Torres died in 1996, people continue
performing his works, extending and replicating them.
People spread the candy, its ideal weight,
and hang the strings of light bulbs, their ideal height,
and print the stacks of paper.
While the instructions are clear, they are not exhaustive—
what shape the candy takes, and where the curtain hangs, all
of this is mutable, a choice.
It means that the pieces keep changing.
It means that the candy I know so well, tucked up in a corner,
could be in any shape,
spread like a heart on the ground, or scattered down a stairway.
What will these pieces look like in twenty years, fifty, more?
What will they look like, as new imaginations take hold?

And how would I look, the patch of black hair between my tits,
the scars on my back, if I put on a silver speedo and danced to
my private songs on a blue square lit by bulbs?

There are many other things I miss about being a faggot—
the specific kind of forbidden, anodyne delight faggots find in,
say, pouring pink wine at a picnic, or rushing about and tidying
things in a fussy way—
but mainly, I miss the love faggots share together,
a kind of soft and hard friendship that endures.
You find out that everything means something different,
when you're a faggot.
You learn that you are lovable after all,
and that once you are done being lovable, you will be ready
to love again.

If I ask Simon to dance, and if he does, the days after will
be a slow slipping away of intimacy, until the right drunken
moment allows us to come back.
Intimacy is uncomfortable, and he turns away from it.
I suppose I do, too, or I wouldn't commit years to this kind of
slow dance.
Maybe it's just that long loneliness of my youth that makes me
think I'm lonely.
We can fuck only sometimes, rarely, and share the same bed
every night.
We can move to Seattle, which will be a new place, where the
mountain is visible from the city.
We'll live close to a leather bar with a pool table.
Like a city we won't live in long, every time we do fuck—
and even worse, every time I put on one of my schlocky songs,
and say,

"Dance with me, please, just a song"—
is both arrival and departure.

It's never clear if or when such pleasure will come again.
Sometimes I think that I could watch Simon dance forever,
and his arms going up a little bit will make us both smile.
Other times, I just wish that I were a faggot, meeting him in
an alley.
But I'm jealous.
I want all the pleasures, every incompatible one.
I'd give myself to them, again, and again,
if I knew how.

I did give myself to those pleasures, I guess, after all—Simon
and I coming together, and then living together. We walked
Otelia's dog together, and we were together on our knees in the
woods with old men's dicks in our mouths, and in the morn-
ings, for breakfast, we ate together, often omelets. Why wasn't
that enough for me? I'm embarrassed that sometimes I wanted
that time to be different, even though it always felt just right.
I think that probably that is why we had to move in different
directions, eventually, because of my dissatisfaction and want.
That seems now like a very sad way to have used my imagina-
tion, although then I would have noticed only how happy I was.
I was very happy, when I loved Simon like that.

Anyway, I don't dance much outside of the house anymore,
mainly because I can't drink alcohol anymore, either, and I'm
sorry but I really don't understand how to enjoy a club sober; it's
a place I would go to drink. One day it was only two beers and
then a devastating migraine, then a week later, a half a glass of
wine with twelve hours of vomiting. I kept trying, goddamn it,

until the end, ordering glasses of soda water with a splash of bitters and a slice of lime, until those, too, did me in flat. I spent all this time googling and googling, never finding an answer, what this could be. All the rabbit holes, forums and talks with a doctor at a clinic, led to nonsense theories: a flood I lived through ten years ago, the antibiotics, Happy Meals. Finally, at a house party that is a fund-raiser for a community bail bond, someone clues me in that it's my testosterone blockers, something about the way they have accumulated in my body, that have done this. Which is ridiculous, because the pills make me feel like I need a drink, actually, to deal with all the bullshit that comes with them. "It has to do with how the Spironolactone is affecting your sodium intake," Torrey clarifies to me later, the perfect swoops of her hair bobbing as she explains something about potassium and off-label prescriptions that I fail to comprehend. "Who told you?" I ask. "How did you figure that out?" And it's always friends of friends, where knowledge like this originates, accumulating like the residual of the pills, one at a time, until eventually something clicks together in the social and it can be known.

There are all these mysteries to a body. Why, or how. This sense that I'm an experiment, that I am coming together. That I need someone else to tell me about me. Within the parameters of myself, it has always been what is unknown, actually, that most bleeds into my other dimensions. That is present.

Jackson and I fall really quickly into a new comfort, of living just the two of us, which neither of us had done before, being always in group houses with single friends, making it together in this big, scary world. My last punk house was in Seattle and it was called the Bitch Palace and his last, Cheap Thrills, was in Australia, but now we jokingly call our apartment "The

Fleischmann-Stacy's." This new living arrangement is partially to make us look good for immigration and state surveillance, and partially it is because I have eked my way into an income for the first time, these sudden new options for living that come when you aren't stressed about finding the next paycheck. It all feels so indulgent, like comfort is a gross pleasure, although I think that every person should have comfort, and that a thing getting in the way of wellness or joy is a political problem. "You know," a friend tells me, "most people don't feel guilty about not living in anarchist collectives." And she's right, of course, but as Jackson and I eat nice home-cooked meals and have clean things and know where the stapler is, it still seems uncanny, this life we've made.

Jackson cracks open the bathroom door while I am showering. "Can I pee?" he calls out.

"What?" I ask. The shower is filled with plants and the leaves are in my face.

"Pee?"

"Yeah!"

"Yeah!" he yells back, really nailing my tone, sounding just like me.

"Yeah!"

"Yeah!" he matches it again, and I keep saying *yeah* to myself after he has left and shut the door, and when I get out of the shower I hear him say *yeah* again a little later, to himself.

One block away from our apartment is the Leather Museum and Archives, and a couple more short blocks is my favorite bar, which is kind of a leather bar and is next to another leather bar I've never been inside. I guess it's a leather neighborhood? To go toward them I walk down the alley a block from my house, which is a grocery store alley. Sometimes people shoot up in the alley, and so I carry my Narcan with my keys. Our apartment is in a courtyard building, with a stone gate with decorative stones at the top that look like butt plugs, and our building management company is called S&M. We don't live with Stevie anymore but down the road is our friend Vicente and then just a little farther in different directions are some other friends. Vicente is a performance artist and when I talk to him about the question "Why aren't we supposed to be next to each other?" he makes in response a performance where he fists a leather daddy in a gallery with the lyric "You make me feel mighty real" looping from the song. The grocery store next to us has a sign outside that says, "Everyone Is Welcome Here." Jackson and I have the front unit in our apartment building. The sun comes through all the windows at different times of day, and sometimes on a Sunday he and I make a large brunch with vegan options and muffins like it's the early 2000s again, and people come and go.

Inside the apartment Jackson and I have sex like my body is taller than his but his body is stronger than mine. And then we have sex like our thighs touch. The kind of sex we have in the apartment is on the couch, kissing, after the last time we had sex was also on the couch, but we didn't kiss much that time. Jackson uses his hands to rub my shoulders and I use my hands to rub his shoulders, also his feet. When we have sex I have ribs, and when we have sex his mouth is open. He uses his fingers to pull on his nipples and when we have sex his hands go

from a part of my body that is closer to my feet up toward the middle part of my body. Inside of our apartment sometimes we come. There are sometimes other people there and Jackson turns so that I am behind him and our bodies each have two points where they bend at an angle. I was scared that I didn't know, actually, how to have sex with the same person all the time when that person is always there, but Jackson and I keep having sex, and it turns out I do know how to do that.

Inside the leather bar there is almost never anyone until very late. In a row on the street outside there is my favorite taqueria, the leather bar I love, a fetish store, that other leather bar, the police, and then the health center where I get my hormones and STI treatments and all that. Inside the bar it's quiet, often just me and whomever I go with, and then at the bar a few regulars whom I sometimes kind of talk to, and the bartender who is always kind. I really like him. "No more bitters in the soda anymore; it's too much for me now," I had to say to him one day. Before midnight or so, the only people who pass through the back of the bar are people going to fuck or sell drugs in the bathroom. The pool table is next to that bathroom, the green fabric of which is loose, and cues that feel hollow and like a hard thing inside of them is loose, too. Also they are all bent. On a back porch and around a little corner into the alley I sometimes take someone to fuck. I press my hand against a brick wall when I do and there is one light. It's always like I might get caught. If someone came outside, he might say, "Hey, go in the dungeon if you want to fuck."

I don't really play with my trauma in sex, just sometimes with control a little bit. I understand that people all the time use sex to engage their trauma, and this is good for them, but I've never

been drawn to process like that. I did convince myself that I should, though, for a while, like how I thought I had to bottom for years. I really believed I would fail my radical queer ethics if I didn't shove stuff up my butt. No one actually told me this or pressured me but I believed it anyway, and it was all my choice, which I got from somewhere else. So I leave my own, personal traumas off the table, and I never developed any real kinks, but my formative years in queerness gave me relatively stable, safe opportunities to try out all kinds of freaky sex shit anyway. I was always curious, and eager, and down for everyone else's perversions. Like I would never have shoved a needle in someone recreationally except that I found myself spending a lot of time with some people who shoved needles into each other recreationally. And although no kinks or real fetishes ever did take hold, I sometimes felt new desires shaping themselves out of my experiences, the roaming that also accustomed me to sometimes having unpleasant, painful, or psychologically convoluted sex. A foot up a friend's ass, or face-fucking someone in a kiddie pool filled with piss, electrocuting and punching and getting beat, none of which is really my thing—all of this made it so that what, a bad blow job, or some stranger trying to fuck me up out of nowhere, it would all be blasé, and I was prepared for it.

Fun and pleasure are productive places to start building resilience, which is good because the work of resisting should feel good when it can. I don't think it's coincidence, this horrible placement of the police station among the leather bars. The Chicago police are murderous; they are trauma, white supremacy, death. I know enough about corruption in this city, and gay bars and police and money everywhere I've lived, that I assume some man is giving some other man something here. That they meet up sometimes, and they give each other what they want,

and that this is why the bar can stay open until sunrise, crime and sin flowing. This is probably a continuation, years of this collective agreement redefining itself, that began in a time with slightly different laws and codes, different bars and men. I don't think there's some deep conspiracy between the leather daddies and the cops, just that they're certainly not distinct groups, not entirely, and a shared aesthetic can be a fucked up thing.

The basement of the bar, where you're supposed to fuck, does look just like the alley. It's called the Hole and there's another bar down there, but they don't even open it until eleven or twelve, when I'm already asleep. Only rarely because of drugs or a party I stay up late enough, and when I do I stand in the middle of the room and I am surrounded by gay dudes and I try to will myself to want to gorge like I used to but it's really just not there anymore. Whatever my first desire was, the one that drove me bursting away from what I knew, toward blow jobs and drag queens and something different, that one is gone and now other desires are there instead. The desire for a transsexual orgy and then a nap. The desire for someone who already knows how to have sex with me right. The desire to not have to talk about it actually. The desire I'm working with now is a thing that I shaped, rather than an inchoate mess, a clumsy what. When I fuck in the Hole I top but I'm not a daddy or a Sir or a boss lady. My desire is about what I'm doing, and what the other person is doing, and we're really not doing a lot, just fucking.

But so much to do! The leather world in Chicago is, like most of the leather world, good at sometimes activating their community into political and charitable action. The Leather Archives are filled with stories of this, and of course meticulous documentation of organizational finances, which has something to

do with doming capitalism, I think. The archives, in their documentation of organizations and community leaders, include important information like, Where did the money go? Who was present and who was in a leadership position? How much cash was raised by this fund-raiser, how much of that cash went to provide services for people living with AIDS, and how much of it went to fight domestic violence in gay communities? Mostly, who got what? This kind of thing tells you a lot— who got what—which is why it should be written down and everyone should know it. Open accounting is a power play too, I guess.

Although saying the right political thing and giving some money, that can just be part of the pageant so no one knows how awful you are. Like a leather daddy Jackson meets, a community figure who specialized in torture with the U.S. military before shifting into what, a similar costume? A similar power position? Whatever the horrors of the United States should be called, they never lack for disguises, new ways to hide in plain sight. Sometimes the people saying the right things, leading the community, and giving a little money to someone who needs it, they can be the last ones you should trust.

Thursdays, the museum is free, which would be a nice way of approaching it, except that the building is not wheelchair accessible, so it's actually bullshit. I attend on some of those Thursdays, take the alley and go into its basement. There I sit in an armchair and read magazines about the leather community, part of the exhibit on women and leather and, on the other side of a floating wall, trans people and leather. On display is the one-year anniversary issue of *On Our Backs,* the pro-sex lesbian

magazine started in 1984, the year after I was born. It is easy to imagine myself into this world. The photographer Honey Lee Cottrell reflects on being featured as the first centerfold in the magazine a year earlier. "Bulldagger Self-portrait," she begins the column, a reflection on her body. "I wonder about butches and nudity as well about aging and nudity. Would you think butches would be more or less willing than femmes to take their clothes off publicly?" She writes about fearing her accumulating experience, "like being permanently bitter over the losses suffered in broken relationships." Alongside is the photo, short hair and an open dress shirt and that look, kind of leaned forward and cocky—if you know that look you know that look. She imagines straight men looking at the photo and getting turned on, and wonders if that would make a guy queer. The Q&A says that she was born not far from where I was born but in 1946. A few pages before this there is a review of a porn film in which a butch person packs a meat sausage from the fridge and runs around the city as a gay man, as well as an advertisement for a store with "X-rated videos for lesbians," World of Video, in Manhattan.

The letters and the personals are beautifully inconsistent, no dominant experience or politics emerging, just some related and incompatible ones. People canceling because of the S&M content, people praising the S&M, people reporting back that everyone at MichFest is trash-talking the magazine. It's all people who know what they want, regardless. "I like menstrual sex, dildos, and fisting. Especially love anal sex. Attracted to virgins, women who do not shave, small tits, and bodybuilders," says one woman. "In heat if you're butch enough to sweep me off my feet—." Another, "Rhinestones are truly you and I know exactly where they should be placed." There are a lot of ads from

Chicago and many of them say "no butches." One particularly femme ad ends, "Must accept heterosexuality."

There is a series of photographs of swollen clits, "The Family Pearl," and an instructional breakdown of biological tissue: "Our new definition of the clitoris helps to explain and validate all women's sexual experiences," which is kind of true—there's a way to squint at its gender language that I like, the word *penis* repeated across the article, a diagram of genitalia that dissolves some binary distinctions. Also inside is a photo series by Cottrell, of "Rachael and Elexis," with Rachael being the first Ms. Leather in 1981, and the first black person to win a national leather title in the United States. The photos close with the couple catching out of a train yard, matching butch and hard-femme leather outfits, an anarchist *A* spray-painted on a car behind them. "Desperate Caboose. Lady of the Eighties seeks bad butch for fast action on the tracks. Coast-bound train leaves tomorrow. Be there . . ."

Behind the magazines, on the lesbian-themed wall, there's a flyer for "Powersurge 1992," an all-women S&M conference, and a little informative placard that explains the group was torn apart internally with arguments over their policy, which stated, "You must be able to slam your dick in a drawer and walk away without causing great physical harm to yourself." Next to it is a flyer with the number and address of the Lesbian Sex Mafia, with a drawing of five dykes on it. Four of them look just like different people I know, all guys. On the other side of the wall there is a celebration of Tyler McCormick, who was both the first trans man and the first person using a wheelchair to win the International Mr. Leather title, in 2010. There's a nice picture of him, at the top of the wall, sexy in a

black leather collar and tie and he looks celebratory. "It is true that I am trans and I have been well received by other trans people but the core of my identity is as a gay leather man," he said in an interview after the win. There's also a boot-blacking station nearby with a looping video so every now and then I hear some daddy, lacing up a boot, joke that "I can't find the hole. That's never happened to me, ha ha."

This is not about inclusion, I don't think, or representation. One night at the leather bar, events are already happening as Vicente and I leave kind of late, and a guy on the stage is drunk: "You all know about the incident," he begins and picks up after a pause to summarize his take on whatever the incident was. "But I think every person should be part of our leather community, whatever her gender." Inclusion is sometimes just more people performing labor to hold up the bullshit. I care more about detailed and welcoming instructions to explore anal sex, which are laid out in one of the dyke magazines, or S&M brunches where everyone brings money for a prisoner support group. Like if every white person who reads this book puts it down right now, goes to a computer, and sets up a monthly recurring payment to a black-led organization. What people do, who has and had what, what they say about themselves—all of that mattering, including who is there.

Anyway, I try not to be scared of violence. It's ceaseless and unavoidable, and you don't want to be scared of something that you'll probably need to use to save yourself. Being scared is no way to live. A lot better, I think, is to remind myself that I'm a fucking badass, and to summon the full power of my imagination, which proves the world malleable, and that the better world is possible. That's what I think about, mainly, in the basement of

the Leather Archives, surrounded by people yelling about dicks, or outside, on the street again.

Maybe all I need to remember is that inside the police station there are just a small number of people who believe that they are in a coalition. And outside the police station there is the world, and some of the police are outside, and some of the people who aren't police are inside. All of us, inside and outside, we should be in a coalition to get rid of the police station, because the police are doing awful things and they have no right to do them, none at all. The police state wants me dead to make sure their children don't end up like me, so I guess every time I fuck and I'm happy and I do what I want I would like to call that an anti-state action. The people I love alive—yes, we weaken the state. But also every time after I have felt pleasure and played pool with a bunch of transsexuals and smoked weed and then eaten a taco and gone home, when my body is at its best, then I need to set myself to contributing to the coalition, which is already underway, which has kept me alive, the work of liberation being one of the ceaseless things.

And I do my best to join that work as a person who has taken the time to heal, because you help other people better once you've helped yourself. This is back in our apartment, Jackson teaching me to put my feet flat on the ground and to breathe and to identify where my strength is inside of me. Healing includes talking and crying, until I feel like I understand what has happened and what it means to me, and sometimes I talk about things from a long time ago, and sometimes from now. Jackson draws from his practice as a body worker, and sometimes I sit and I think of all the people who have survived who I did not think were going to survive, and then I think of myself alive. Some nights we gather

all the houseplants and put them in the bathroom, then we run the shower all the way up to get everything steamy and light candles, and then we run a hot bath and sit in it together, what Jackson calls a Jurassic Sauna, with a Sade album on. And after that I eat some homemade kraut out of a stone crock, and then I'm ready to be a person doing something, and to think about what I'm doing, and who I'm doing it with.

After Jackson visits New York and sees a Felix Gonzalez-Torres retrospective there, I buy the next cheap flight and make sure to catch it before the close. It's just a weekend trip for me, a short flight from Chicago to sleep at Cyd's apartment and then back. Before I go Jackson gives me a pink padlock with *Love me go away* engraved on one side, and we lock it on the railing of the pier by our house, so it will be there when I'm not. I cry when he gives it to me and then I say "babe" and keep kissing his cheek when we hang it. Being so quickly in Chicago and then New York and then Chicago again, right away, feels like too much to me. I'm used to the long approach, of strangers I found on Craigslist driving me over a long night, and then days of settling into the rhythms of a different city. Another way it confuses: having a little money like this job is giving me, and then every single thing being different because of it.

I ask Cyd to come to the show with me. First I get really high and talk about aliens with Avory for a couple of hours, and then I go to the gallery, and then Cyd meets me there. He and I recently stopped hooking up, not like a breakup because there is no breaking, just like a very nice connection that can be many things and remain a very nice connection. Most all the work in the exhibit is stuff that I've seen before but it's still nice to encounter it again and touch it, and also nice to encounter it with

someone like Cyd, who hasn't already bogged the work down with his own thinking. *"Untitled" (Go-Go Dancing Platform)* is there. The platform is empty when I first arrive at the gallery, and unpopulated also after I go to get coffee and come back with Cyd. We sit for a bit in case we can catch the dancer, but we both eventually lose patience. Instead, I just tell him that a go-go dancer will come out eventually, and I remember the picture Jackson sent me the week before, where he's breaking all the rules and looking very happy, up on that platform and dancing, how he usually looks when he's doing something nice for me, but this time with light bulbs in a square around him.

There is a really nice piece, a VHS tape that plays on a loop, that I haven't seen before. I'm taken by VHS tapes in that obnoxious way people favor the aesthetics of older media. The pleasure I get from them isn't a recall of my childhood, but a reminder of the way VHS rentals offered a portal out of my childhood, into other realities and timelines—the hope that with a remove into ephemera, that maybe I'd be gone soon, too, slipped right into that return slot. VHS also reminds me of Simon and the first nights I spent in his bed watching the same tapes he'd been watching for his entire life, *Party Girl* and Gregg Araki movies and *The Client* as he recovered from a motorcycle having run him over. He also had a modest collection of gay porn tapes, Fred Halsted and other directors who made masculinity arty in an easy way. There's something erotic about lying in bed watching a VHS— the sense that you're there until the end, that whatever tensions are present are going to mount with the film's progress, like a VHS is somehow harder to pause, and has to be finished.

The video is *"Untitled" (A Portrait) 1991–1995* and it is five minutes that loop for an hour, four years cut down to a quick

sequence of light. There are a couple of chairs in front of it so Cyd and I sit and watch. Whenever we're together I want to hear what Cyd has to say and then end up talking more than him and feeling annoyed with myself later. The video is just white text on a black background, phrases in all lowercase that fade in, stay for a few seconds, and then fade out again so that another bit of text can appear somewhere else on the screen. Most of the phrases are on the bottom but some of them are on the top or in the middle. They're like that other text portrait, the typed-out one, but without years listed alongside the phrases. I try to search a few phrases on my phone to see if the text is available anywhere online and when it's not, I decide to record it, setting my phone fake-discreetly on my lap as I continue chatting with Cyd. I don't start recording at the beginning of the tape but somewhere in the middle, and my phone slips at some point so I don't catch a couple of the phrases at the top of the screen. I don't take any of it in while it's scrolling past because instead I'm talking the whole time with Cyd about a friend of ours neither of us has seen in a while and also about how the longevity of interest in Felix Gonzalez-Torres's work relates to the artist's death, which Cyd asks about.

My own video is pretty awful to revisit because I hate listening to my voice, and also the way I try to explain Gonzalez-Torres stumbles into generalities and half-truths. Sometimes there are moments of silence when the language floats on the screen, *a night sweat* and *silver ocean* given space away from my stuttering voiceover, and later, after the tape has come back to the front, *a found black cat* and *long love letters* get one long silence, one phrase immediately following the other. When I talk about the possibility of having an erotic and embodied encounter with the work without realizing the encounter is erotic and embodied,

like how I think a lot of people eat the candy, the screen says, *an environmental disaster.* The pause between phrases on screen takes a second, too, so when I say, "I hope to do that," there aren't any words, just the blank screen. I say "like" during *a view to remember, a simple ocean, a bounced check,* and *a wet lick on his face,* and Cyd "ums" and "yeahs" during *a wet lick on his face* and *many possible landscapes,* and then during *a possible landscape.*

There might be something to the way I hate hearing my own voice but love the sound of my friends' voices. The beauty in a voice is how it fills space, how it can move an idea through your body and then out into the room, away from you. Like when I am in a room filled with people I love and everyone is talking to each other, the voices all sounding together, dissonant dissidents. Cyd's voice is soft, like a trill, and I'm delighted when I hear it. I'm not sure how my voice today sounds in relation to the faggy, nasally pep my Midwest youth gifted me. It doesn't feel like there were any choices in it, or maybe, rather, the choice was to tune it on the page, where I can hear what I'm saying without the sound getting in the way.

I appreciate that *"Untitled" (A Portrait) 1991–1995* doesn't tell me what it's a portrait of. It's a portrait of what it's a portrait of, I'd say, if someone asked me about it. The order of it means that sometimes the broader cultural and political problems align with the personal exigencies they create, like *a bounced check* followed by *a rise in unemployment,* but more often there's an uneven rhythm to those connections, *a white blood cell count* and then *silver ocean* and then *a distant war.* Like I grew up thinking I was singular, but the world kept revealing itself to

me, until I understood that I was not. The VHS is one hour of the same repeating five-minute progression. I wonder if someone is going to come out and switch it every hour, and how that timing aligns with the go-go dancer, if they see each other sometimes or never, then I remember that most VHS players flip the tape on their own, and continue.

Cyd takes off—"Bye honey," he always says when he leaves, and "Hi honey," he always says when he arrives—and so I have some time to kill in Manhattan. I start walking toward the piers and call Simon. I like to call him when I'm in New York so that we can talk about the city together and toss around variations of why we do or do not miss it. Simon and Cyd were friends way back too, in a city where I've never spent much time and from which most people I know have been priced out, so a lot of things around me feel embedded in the past as I talk to him, walking and wishing I still smoked cigarettes. I do not miss New York this time, already thinking of my return to a teaching life and an apartment by the beach, and Simon is conflicted, recalling what he enjoys of the city—the smell of trash, the anonymity—but not desiring to center his life there, either. We talk about our drunken nights as the water laps the piers and I miss him.

Anyway, you never get there, you just keep going. Things are repeated, and sometimes we mistake the fact of their repetition for their value. It can make it seem like we aren't supposed to change, or like our love has to be just so. It can make it seem as though what we know is best, which it only sometimes is. But maybe that's okay. Even when imagining takes us away, it still begins with what's already here.

Maybe that's why I'm always catching myself in a daydream,
where Simon and I are holding hands, and going exactly
where we should be.
Because that's what I dream of, places like that.
Where Simon likes holding hands,
and everyone recognizes our collective beauty,
a thing that is here now but also very far from what we know.

Like a mirror with my face pressed up flat against it, pressing against my own story. The most horrible things pressed up close to the most wonderful, the most wonderful things pressed up close to my cheek. Flat, stubbly, porous, like the moon battered to mares. A pale body with a penis hanging limp, a beautiful image of me that I cannot own. This always was a very erotic exercise.

If the aliens do show up, I hope they'll see people they want to save. Friends and magnificent sluts, smashing the walls of the prisons and burning all the money, running around with signs that declare our liberation. Our hands up in the air and then down again, like some people in love. Our hands taking from two stacks of paper, "Nowhere better than this place" and "Somewhere better than this place." Just a small part of the relentlessness of people in love, finding ways to make pleasure through all time. With losses that are shared and that no one else knows. I guess that's what the story is. A story of bodies that are different, of people who fuck up and make each other happy and then die. Where everything is impossible and so we try to make it real. Where it's spring, and the season of ice has passed.

. . . Ice is not a pellucid thing, but a disarray of fissures and air. Is not something that is cold but is something that is frozen and feels cold when your hand presses down upon it, then later seems warm to your hand. Is not quiet but is loud and is not a color but is several colors at once. Is not vulnerable nor dangerous, but might be one day a flood after sunlight, or a weight so heavy it moves itself, and carves smaller the earth . . .

. . . Ice on old wood makes me want to lick it, to feel the grainy stuck part of the wood and the smooth part of the ice. Tongue might stick. Wood grain swirls into itself like ice freezes into its water, and when the dew of morning settles in the dented weaves of wood the dew freezes to little crystals. Cedar has that shimmer, too, when it is first cut and sappy purple. A big old building as big as a barn in the center of a cold town gets covered in ice crystals every winter morning, months on end, and you would need to scrape at its wood with your fingernail to break . . .

. . . that move directly from solid to gas that results in frost spicules, in fine and stiff white spikes, in two kinds of cold that are cold enough for advection and for the crystalline prickle across the plane . . .

. . . fracture. Split through, split apart, split into and out of blue. Split so the split is black and the ice is white. Split with tendrils of crack. And where it is still whole and hard, there beside the split it is whitest, although the whitest whites are just smaller splits, cracking the fractured ice into itself and out of its blue. A fog of small splits about each break and a hard dark split so there is no whole, just a clear ice and a clear ice. Because I lifted the block, wetting my hands on the white, dropped it onto the gray slate of creek rock. Because my hands ache from touching the ice. Because I can now put the two whole ices one atop the other, the white splits and dark crack splits each finding a fracture to match. And because the ice melted to water by my hands can find the static hum of the splits and fill and quiet them. Tonight it will grow colder and colder still and grow still in the colder, and the mends will become rends, and it will restore a clear hum. And maybe then I will have a block of ice again, to break . . .

. . . or the sheen of ice screeches. The sheen of ice screeches white ice screeches. The white sheen of silver ice screeches. The silver screech of ice has a sheen. The sheen of ice screeches, screech screech, and it was a sheen. It had a sheen, the silver ice. The silver ice has a sheen. Let's sing . . .

NOTES

Page 4: Information about Felix Gonzalez-Torres comes from a range of sources. I'm grateful to the staff at the MoMA library, who made it easy for me to access their resources. I am also appreciative of the two books I first used to orient my thinking—Nancy Spector's *Felix Gonzalez-Torres,* published for the Guggenheim in 1995, and Julie Ault's 2006 edited collection for Steidl Publishers, also called *Felix Gonzalez-Torres.* I also thank Visual AIDS and the Felix Gonzalez-Torres Foundation, who allowed me to spend time with the correspondences and ephemera donated by Carl George, and to Alex Fialho in particular for assistance in arranging that visit.

I don't want to claim any expertise on the artist, and hope to engage with his work horizontally—if anything, opening up space for further meaning rather than exerting any sort of authority. But it really helped me to think—encountering his work did—and I am appreciative of that, and hope to share some of it.

Page 23: My favorite writing about this kind of relationship, like with Cyd, also comes from Delany. In his 2017 essay "Ash Wednesday," published by the *Boston Review,* he offers, "It is very easy to divide the world into binary groups and then a supplementary group is postulated as a mediator: friendship, affection, sex, celibacy. Raw, cooked, boiled, burnt. Hell, purgatory, paradise. Conscious, unconscious, dreaming."

Page 27: The book Simon and I pass back and forth is Joanna Kavenna's *The Ice Museum: In Search of the Lost Land of Thule* (Viking, 2006), which I used for much of the information on Thule in this section.

Pages 31–32: Gonzalez-Torres quotes in the section that falls across these pages are from "1990: L.A., 'The Gold Field,'" in the catalog for Roni Horns's *Earths Grow Thick* (Wexner Center for the Arts, 1996).

Page 32 (bottom): Quote is from an interview with Gonzalez-Torres by Ross Bleckner in the April 1995 issue of *BOMB.*

Page 33: The detail of hunters returning to find the Thule Air Base under construction comes from Mike Davis's *In Praise of Barbarians: Essays against Empire* (Haymarket Books, 2007).

Page 34: Quote is from a 1995 interview with Gonzalez-Torres by Robert Storr, originally in *Art Press,* and reprinted in Ault's book.

Page 35: Quote is from a conversation between Gonzalez-Torres and Joseph Kosuth in *A. Reinhardt, J. Kosuth, F. Gonzalez-Torres: Symptoms of Interference, Conditions of Possibility* (Academy Edition, 1994).

Page 36: The Gonzalez-Torres quote is from "1990: L.A., 'The Gold Field.'" The Roni Horn quote is from an interview by Mimi Thompson for *BOMB* in 1989.

Page 39: The quote from Agnes Martin appears in a 1976 interview with John Gruen, collected in *The Artist Observed: 28 Interviews with Contemporary Artists* (A Capella, 1991).

Page 43: The conference I attended was Queer Circuits in Archival Times.

Page 51: The conversation with Tim Rollins was originally printed in *Felix Gonzalez-Torres* (A.R.T. Press, 1993).

Page 60: *Post-Scarcity* was created in collaboration with Benjy Russell and is included with permission.

Page 63: This excerpt is also taken from the conversation with Tim Rollins in *Felix Gonzalez-Torres* (A.R.T. Press, 1993).

Page 71: I primarily used two books to gather information about Publick, *The Public Universal Friend* by Paul B. Moyer (Cornell University Press, 2015) and *Pioneer Prophetess* by Herbert A. Wisbey Jr. (also Cornell, 1964). I am also appreciative of Scott Larson's "Indescribable Being" in the journal *Early American Studies* (fall 2014), which was the first thing I read about Publick that understood their gender, and also the first writing that meaningfully engaged them as a settler.

For information on the Treaty of Canandaigua, I relied on *Treaty of Canandaigua 1794,* edited by G. Peter Jemison and Anna M. Schein (Clear Light Books, 2000). I am grateful to those editors, and to the writers in the collection.

Page 100: Postcard quote is from the Carl George archive.

Page 106: The Pasolini quote comes from a 1950 letter to Silvana Mauri, available in his collected letters, which were edited by Nico Naldini and published by Quartet. I came to the press release mentioned later on this page when I purchased a bag the artist Dean Sameshima had screen-printed it onto. The translation is by Lawrence Ferlinghetti and Francesca Valente.

Page 114: Information about Pomp Kersey is from *Cannon County*, part of the Tennessee County History Series (Memphis State University Press, 1982).

Page 136: I found the information about the first Ms. Leather contest on the website *Leatherati* and the series Black n Leather, written by Tyesha Best. The interview with Tyler McCormick is by Oscar Raymundo, from *Queerty* in 2011.

Page 137: If you're a white person who hasn't started paying reparations, you can do it in many ways, including direct monthly payments to individuals and monthly recurring donations to black-led organizations, similar to how you might dedicate a monthly share of your housing expenses to the indigenous people whose land you occupy. You can google "black-led organizations" right now to get started.

Page 139: This was the retrospective of the artist's work by the David Zwirner and Andrea Rosen galleries.

ACKNOWLEDGMENTS

Thanks to those who appear in this book. I changed names or identifying information when appropriate, but most appear as they do in my life. For the generosity of letting me render you in this project, thank you. This is especially the case for Simon, and for Jackson.

And to Benjy Russell, Cyd Nova, Vicente Ugartechea, Maya Victoria, Finn Oakes, Christopher Soto, Avory Agony, Mev Luna, Otelia Lundberg, Calvin Burnap, Louise Fleischmann, Ryan Greenlee, Benjamin Haber, Torrey Peters, Jackie Wang, Kate Zambreno, May, Bee, Talka Wiszczur, Stevie Hanley, Sterling, and Elyza Touzeau. Ideas in conversation with these friends helped me greatly in thinking about this project.

I have been fortunate to work in the classroom with uncommonly insightful students and writers. I thank them for sharing their work with me.

Thanks to H Melt, for inviting me to read in front of *"Untitled" (Water)* at the exhibit Art AIDS America.

Portions of this text appear, usually in significantly different forms, in the *Kenyon Review Online,* the PEN Poetry Series, *Clockhouse, Fanzine,* and the anthologies *How We Speak to One Another* and *Little Boxes: Twelve Writers on Television* from Coffee House. Thanks to those editors.

Coffee House Press began as a small letterpress operation in 1972 and has grown into an internationally renowned nonprofit publisher of literary fiction, essay, poetry, and other work that doesn't fit neatly into genre categories.

Coffee House is both a publisher and an arts organization. Through our *Books in Action* program and publications, we've become interdisciplinary collaborators and incubators for new work and audience experiences. Our vision for the future is one where a publisher is a catalyst and connector.

LITERATURE
is not the same thing as
PUBLISHING

Funder Acknowledgments

Coffee House Press is an internationally renowned independent book publisher and arts nonprofit based in Minneapolis, MN; through its literary publications and *Books in Action* program, Coffee House acts as a catalyst and connector—between authors and readers, ideas and resources, creativity and community, inspiration and action.

Coffee House Press books are made possible through the generous support of grants and donations from corporations, state and federal grant programs, family foundations, and the many individuals who believe in the transformational power of literature. This activity is made possible by the voters of Minnesota through a Minnesota State Arts Board Operating Support grant, thanks to the legislative appropriation from the Arts and Cultural Heritage Fund. Coffee House also receives major operating support from the Amazon Literary Partnership, the Jerome Foundation, McKnight Foundation, Target Foundation, and the National Endowment for the Arts (NEA). To find out more about how NEA grants impact individuals and communities, visit www.arts.gov.

Coffee House Press receives additional support from the Elmer L. & Eleanor J. Andersen Foundation; the David & Mary Anderson Family Foundation; Bookmobile; Fredrikson & Byron, P.A.; Dorsey & Whitney LLP; the Fringe Foundation; Kenneth Koch Literary Estate; the Knight Foundation; the Matching Grant Program Fund of the Minneapolis Foundation; Mr. Pancks' Fund in memory of Graham Kimpton; the Schwab Charitable Fund; Schwegman, Lundberg & Woessner, P.A.; the Silicon Valley Community Foundation, and the U.S. Bank Foundation.

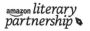

The Publisher's Circle of Coffee House Press

Publisher's Circle members make significant contributions to Coffee House Press's annual giving campaign. Understanding that a strong financial base is necessary for the press to meet the challenges and opportunities that arise each year, this group plays a crucial part in the success of Coffee House's mission.

Recent Publisher's Circle members include many anonymous donors, Suzanne Allen, Patricia A. Beithon, the E. Thomas Binger & Rebecca Rand Fund of the Minneapolis Foundation, Andrew Brantingham, Robert & Gail Buuck, Dave & Kelli Cloutier, Louise Copeland, Jane Dalrymple-Hollo & Stephen Parlato, Mary Ebert & Paul Stembler, Kaywin Feldman & Jim Lutz, Chris Fischbach & Katie Dublinski, Sally French, Jocelyn Hale & Glenn Miller, the Rehael Fund-Roger Hale/Nor Hall of the Minneapolis Foundation, Randy Hartten & Ron Lotz, Dylan Hicks & Nina Hale, William Hardacker, Randall Heath, Jeffrey Hom, Carl & Heidi Horsch, the Amy L. Hubbard & Geoffrey J. Kehoe Fund, Kenneth & Susan Kahn, Stephen & Isabel Keating, Julia Klein, the Kenneth Koch Literary Estate, Cinda Kornblum, Jennifer Kwon Dobbs & Stefan Liess, the Lambert Family Foundation, the Lenfestey Family Foundation, Joy Linsday Crow, Sarah Lutman & Rob Rudolph, the Carol & Aaron Mack Charitable Fund of the Minneapolis Foundation, George & Olga Mack, Joshua Mack & Ron Warren, Gillian McCain, Malcolm S. McDermid & Katie Windle, Mary & Malcolm McDermid, Sjur Midness & Briar Andresen, Maureen Millea Smith & Daniel Smith, Peter Nelson & Jennifer Swenson, Enrique & Jennifer Olivarez, Alan Polsky, Marc Porter & James Hennessy, Robin Preble, Alexis Scott, Ruth Stricker Dayton, Jeffrey Sugerman & Sarah Schultz, Nan G. & Stephen C. Swid, Kenneth Thorp in memory of Allan Kornblum & Rochelle Ratner, Patricia Tilton, Joanne Von Blon, Stu Wilson & Melissa Barker, Warren D. Woessner & Iris C. Freeman, and Margaret Wurtele.

For more information about the Publisher's Circle and other ways to support Coffee House Press books, authors, and activities, please visit www.coffeehousepress.org/pages/support or contact us at info@coffeehousepress.org.

T Fleischmann is the author of *Syzygy, Beauty* and the curator of *Body Forms: Queerness and the Essay.* A nonfiction editor at *DIAGRAM* and contributing editor at *Essay Daily,* they have published critical and creative work in journals such as the *Los Angeles Review of Books, Fourth Genre, Gulf Coast,* and others, as well as in the anthologies *Bending Genre, How We Speak to One Another, Little Boxes,* and *Feminisms in Motion.*

Time Is the Thing a Body Moves Through was designed by
Bookmobile Design & Digital Publisher Services.
Text is set in Adobe Garamond Pro.